IMAGES
of America

CHATTAHOOCHEE
VALLEY RAILWAY

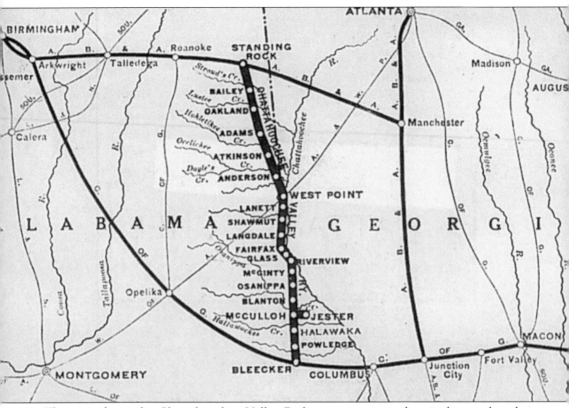

This map shows the Chattahoochee Valley Railway as it appeared at its longest length in 1916. The short-line railway was centrally located between Birmingham and Montgomery, Alabama, and Atlanta and Columbus, Georgia. It followed a portion of its namesake river, the Chattahoochee.

IMAGES
of America

CHATTAHOOCHEE
VALLEY RAILWAY

Tom Gallo

ARCADIA

Published by Arcadia Publishing,
an imprint of Tempus Publishing, Inc.
2 Cumberland Street
Charleston, SC 29401

Printed in Great Britain.

Library of Congress Catalog Card Number applied for.

For all general information contact Arcadia Publishing at:
Telephone 843-853-2070
Fax 843-853-0044
E-Mail arcadia@charleston.net

For customer service and orders:
Toll-Free 1-888-313-BOOK

Visit us on the internet at http://www.arcadiaimages.com

*This publication is dedicated to the employees of the Chattahoochee Valley Railway,
recognizing their devoted, efficient, and friendly service that helped keep the textile industry
they served prosperous. While providing 97 years of safe and dependable service,
they always invited visitors like myself along for the ride. My hope is that this
story reflects their hard work and pride adequately.*

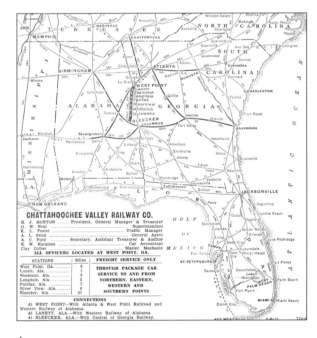

This image provides a geographical perspective of the United States. Larger connecting railroads such as the West Point Route, Central of Georgia, and Atlantic Coast Line relayed freight cars of raw cotton to this short line from Georgia, Alabama, Mississippi, Texas, and California.

4

CONTENTS

ACKNOWLEDGMENTS

The outpouring of assistance by so many makes an author's work much easier and ensures that the final product covers key elements. Although the Chattahoochee Valley Railway was comparatively small and secluded, help to the author came from people located up and down the East Coast and along the Mississippi River states. Thank you to everyone.

One of those who provided immense support is my wife, Lona Joyce. Her outreach over the internet resulted in those hard-to-find images. Two special people who continued to encourage me to complete this project, originally conceived in 1991, are Miriam Syler of the Cobb Memorial Archives and my sister-in-law, Harriette Buckenham.

Thank you to West Point Stevens, Inc., and Toni Cauble, vice president of public information, for their permission to use archival images. Larry Goolsby of the Atlantic Coast Line Historical Society was equally generous in providing key images.

My sincere thank you to Faye and Ralph Beck, Councilman William Beck, John Brinckman, Wayne Clark and the *Valley-Times News*, Don Cogdell, William H. Cooper, Bill Gilbert, Forrest and Mary Louise Hornsby, Charlie Houser, Collette King, Thomas Lawson Jr., Councilman Arnold D. Leak, Richard Ledyard, William Longo, Gerry Meacham, Randall Moody, Lavinia Morgan, Joe and Joyce Nabors, Gordon Neal, Leroy Pigg, Rick Perry of Rail's End, Rob Richardson, Curtis Rimler, Howard L. Robins, Joel Rosenbaum, Jeff Silverman of Silverman Photography, El Simon, Harold Smith, Virginia Smith, STAPLES of Hazlet, New Jersey, and manager Joe Secula, Gary, Lou, Nicole, and Shannie, Carl Summers, Ron White, Wylene Wilderson, R.W. Young, George Zachry Jr., and Margaret Zachry.

INTRODUCTION

The Chattahoochee Valley Railway was one of America's many short-line railways. Its main purpose was to deliver raw cotton to the textile mills of the West Point Manufacturing Company located along the Chattahoochee River in east central Alabama. The Chattahoochee Valley Railway was called the "CV" locally, and so respectfully, it shall be herein.

The pioneers of the textile industry in this area required a dependable transportation method to transport tons of raw materials and finished products. Mule-drawn wagons on dirt roads and barges on the nearby river were never going to handle the anticipated textile business growth. Railroads were already a success in America, having proven their value when it came to hauling heavy loads. The textile leaders knew they needed a rail line that they controlled to connect at the city of West Point, Georgia, which was already a leading trading point. The Western Railway of Alabama (W of A) reached West Point in 1851. The Atlanta and West Point Railroad (A & WP) connected there in 1854, creating a company known as The West Point Route (WPR).

The Chattahoochee Valley Railroad (not yet the Railway) was incorporated in Alabama on July 2, 1895, "to build a railroad from Langdale to a point in Lanett," adjacent to West Point. After less than a year of operation, Treasurer Horace S. Sears reported a $2,700 profit. This good news in June 1896 resulted in a stockholder vote to authorize an extension of the railroad from Langdale to River View, thus providing a rail connection to both of the original 1866 mills located in those towns. An excerpt of a report made by President LaFayette Lanier at the first annual stockholders meeting on December 17, 1896, at West Point offered the following about the new company:

> The railroad has been operated without incident...and has saved [parent] West Point Manufacturing $1,700 on transportation costs over previous methods...Passenger fares are yet only a nickel...Outside freight [non-mill related] is about 22% of our revenue, but I hope to increase this when a new depot is built at Langdale...The extension to River View will be completed by April 1897...

On April 17, 1900, the original CV Railroad was dissolved, and a new company, the Chattahoochee Valley Railway, was incorporated in Georgia. With a goal to connect with other railroads in addition to the WPR to take advantage of the best freight car interchange tariffs, CV management looked north and south. The first extension of the rail line went south of River View in 1899 to Bartlett's Ferry (Jester). Looking for another connecting railroad, the

CV built northward to Standing Rock, Alabama, connecting with the Atlanta, Birmingham, and Atlantic Railroad in 1908. A final extension southward from Jester in 1916 to Bleecker, Alabama, connected the CV to the Central of Georgia Railway. The CV was now at its longest length of 45 miles, with a total of three connecting railroads!

New mills were built along this rail line, that not only added to the CV's revenue, but also, in some cases, created new communities. Sequentially, southward from Lanett, the Shawmut Mill opened in 1908; the Services Division in Langdale opened in 1940; Fairfax Mill opened in 1916; a new West Point Utilization Company facility opened in 1942, and the Central Warehouse opened in 1960 (both located in the community of Glass); and the Lantuck Mill opened in Fairview in 1955.

To provide service and handle the increasing delivery frequency and loads, the CV consistently needed to purchase more powerful locomotives and additional freight-carrying equipment. Locomotives 1, 2, 5, 7, 100, and 101 were purchased new from various manufacturers over the years. Other locomotives were acquired used from neighboring railroads. Boxcars, used for transporting general merchandise, and cabooses were bought both new and used. The CV converted some of its boxcars into wood pulp cars, earning additional revenue hauling wood pulp.

Relocations of the CV's track and right of way are an interesting part of its history. The Highway 29 widening project had the most impact, creating a sub-chapter of engineering intrigue as the mainline was realigned to pass under instead of over the WPR, while vacating the streets of Shawmut. A 1924 hydroelectric plant and Bartlett's Ferry dam building project required 2 miles of CV mainline be protected. That protection included two new steel bridges to carry tracks over the created backwaters of the Osanippa and Halawaka Creeks. As vehicular traffic grew in West Point, relocating the CV main line out of the streets was a necessity.

During the Depression, the CV was approved by the Interstate Commerce Commission in 1932 to abandon all tracks and services from West Point to Standing Rock. In the same year, approval to discontinue all passenger service on the CV was granted. While many employees lived close enough to walk to the mills, automobiles were making their appearance, which dipped into passenger revenues.

In 1941, the CV and owner parent West Point Manufacturing Company management separated, although ownership was retained. The CV's main business was still textile oriented. A new type of motive power, known as a diesel-electric locomotive, was purchased in 1946. It was inspected by local citizens like Lavinia Morgan, seen in the window on the back cover. It provided plenty of horsepower, without the laborious maintenance processes of steam locomotives. Diesels would eventually eliminate expensive coal handling facilities and water towers. Less track configuration for turning steam locomotives, know as a "Y," were needed, further reducing maintenance and infrastructure costs.

A 1951 study found the CV in good fiscal and physical condition with its $57^1/_2$ employees. (Bleecker was a joint agency. Although a Central of Georgia employee, the agent's salary was half paid by the CV.) Consideration was given to abandoning the line from River View to Bleecker to save operating costs. The idea was ruled out so that the CV would not be held captive to high tariffs with no alternative connection. The wood pulp business in the early 1950s generated a reaction from the CV. Shop employees made wood pulp cars from some of the railway's own fleet of boxcars. These were the only CV cars that ever left their property. Before then (and never again after the wood pulp cars were scrapped) CV interchanged its own equipment. The carrier was not in the business of leasing out cars like the bigger railroads. Cars of other railroads, referred to as foreign cars, came and went continually. While referred to as the "CV," all equipment of the Chattahoochee Valley Railway was prefixed "CHV" to differentiate between the Central Vermont Railway, whose official markings were CV. (No two railroad cars in the United States can have the same identification for safety and tracking reasons.)

Fluctuating cotton prices, increased trucking competition, and the need to construct a dam

north of West Point provided additional revenue opportunities to the CV in the 1960s. The Central Cotton Warehouse was built by West Point Manufacturing Company to buy and store cotton when prices were low. The CV was required to handle lengthy strings of inbound boxcars when prices were right. Cars were unloaded at the huge warehouse, allowing the CV to return foreign cars quickly to connecting points to save rental costs. After the cotton was sorted, the CV would redistribute the various grades to different mills locally in its own "CHV" boxcars. There was very little cotton wasted. Even sweepings from the floor were used to make mop strings and such. In 1961, with the end of steam locomotives on the CV at hand, #21 made its last run in grand splendor. The trucking industry was taking its toll on railroads nationally. The CV set up a transfer ramp to handle trailers on flat cars known as "piggybacks," hoping to generate local interest for truck rail shipments.

In order to reduce the repeated flooding of West Point, the U.S. Army Corps of Engineers constructed a dam north of that city. The CV was extended from West Point north, requiring the replacement of a wooden trestle with one of steel. The CV handled shipments of slag and aggregates over its entire length from Bleecker to keep up with the dam construction. More motive power was acquired, as rail shipments for the dam could not impact the textile business.

The completion of the dam in 1973 brought about a final change in the CV that would last to the end. The extension to the dam was abandoned—there being no other customers to serve. The line from River View to Bleecker was also abandoned as the CV attempted to cut track maintenance costs. Discussions with the Central of Georgia, through new owner Southern Railway, to maintain this section of track never materialized. With the wood pulp business long gone and the dam shipments through Bleecker ending, little traffic was anticipated over the south end, leading to its abandonment. The CV management, long time friends with the management of the WPR, trusted reasonable rates would be in effect, as the short-line opted to have just one interchange connection at West Point.

The relocation of the CV's headquarters and shops occurred in 1974 when it leased the A & WP's antebellum headquarters, located directly across Highway 29 from its own. The abandonment of the CV shop and yard in Lanett allowed for new construction of commercial establishments in town. The CV piggyback business was given up in 1980, as major city terminals were the only place WPR fast freights would stop to set out cars.

By the early 1990s, the textile company had changed several production methods within the mills, which would have required the realignment of the CV's tracks at each mill. It was less expensive to build loading docks for the in-house fleet of trucks. The parent textile company, several mergers later, was now West Point Stevens Incorporated. It concluded that the CV's services were the most expensive option to use as a transportation mode for its business. A private short-line operator concurred and passed up an invitation to operate the line. The CV's last day of rail service was September 25, 1992.

Local residents and officials, always friends to the railway, attempted to save the CV as a tourist line. A study concluded it would be a risky financial venture. While the textile industry lived on, the tracks of the CV were dismantled in 1993. A portion of the Chattahoochee Valley Railway has become a hike bike trail, providing a recreational heritage path through Valley, Alabama. Join us now for a trip back in time through images of the Chattahoochee Valley Railway.

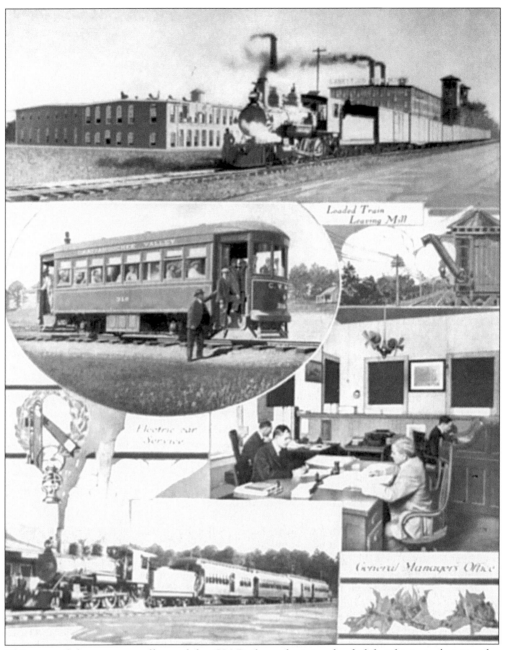

This turn-of-the-century collage of the CV Railway depicts a loaded freight train leaving the Lanett mill (top); a wooden water tower to replenish steam locomotives; the railway's general manager's office; a typical passenger, baggage, and mail train; and an electric storage battery car with seated women travelers wearing beautiful bonnets, while the gentlemen board last.

One

Equipment
to Do the Job

The Chattahoochee Valley Railway had a big job to do, despite its small size designation as a short-line carrier. Tons and tons of cotton and textile products had to be transported expeditiously. The terrain included small hills, meaning extra pulling power was required of its locomotive fleet to climb grades exceeding two percent. Passengers and mail were accommodated in an era before automobiles and electronic communications. Shops to maintain the equipment, maintenance machines to keep the tracks and bridges in good condition, and stations and fueling facilities were all a necessity. The CV bought new and used equipment and employed many local people throughout its 97 year history.

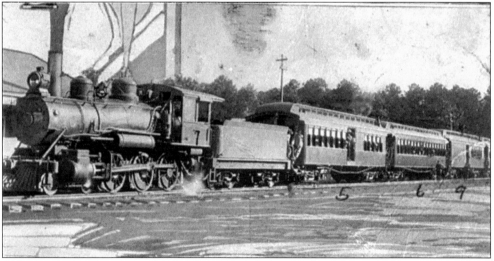

CV steam locomotive #7 and its tender are coupled up to four of the railway's passenger cars. They are a combination passenger and baggage (combine) #5, coach #6, combine #9, and coach #3 (out of view). A close look shows everyone posing. Since most small railroads did not operate two combines in one train, this train was likely staged for the camera. Number 7 was purchased new in late 1907.

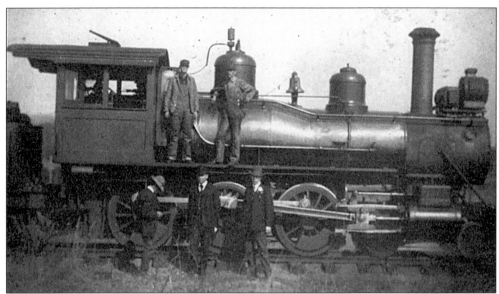

Locomotive #3 poses here with standing engineer Beecher Dennis (left) and fireman Lloyd Allen. Checking the time on his watch, an important operational procedure, is flagman Coon Blanton. Flagmen protected their train using a flag by day or a light by night, standing far enough away from their stopped trains to warn oncoming trains on the same track of danger. In the center of this image is Joe Dennis, and conductor John McGlon is to the right. The conductor was ultimately responsible for the safe operation of his train.

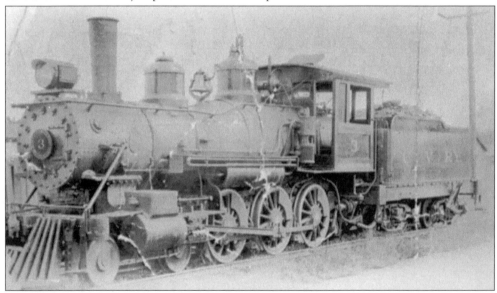

The Baldwin Locomotive Works built #3 in May 1903. The CV purchased it from the nearby LaFayette Railroad in 1909, selling it in April 1, 1929. Steam locomotives were designated by type and wheel arrangements. In the front, the smaller non-powered wheels served as pilots. The next set, linked by rods, provided the power to turn the wheels, as steam passing through alternating chambers pushed and pulled the rods. The trailing set served to balance the locomotive and provide support. Number 3 was a 4-6-0, indicating it pulled with six wheels and had no trailing wheels.

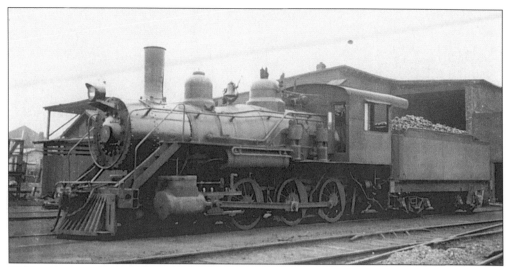

CV locomotive #9 was built in March 1912 by Baldwin and purchased new. It was a 4-6-0. The CV sold it July 1, 1940. The roof over the cab was originally of wood but was destroyed in a fire. The CV rebuilt the roof using the metal from a water tower. Efficiency and money saving techniques were a mainstay of CV management, resulting in healthy stockholder dividends. Number 9 stands ready, loaded with coal, in front of the original shop in Lanett.

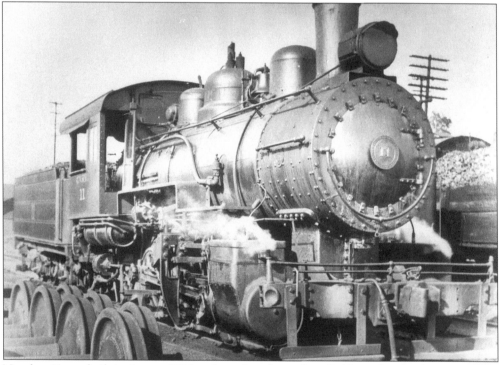

Number 11 was built in August 1919 and purchased new from Baldwin. Its wheel arrangements of 0-6-0 designate it as a switcher. Switchers generally did not leave railroad yards and traveled at slow speeds, reducing the need for pilot wheels. When called upon, they could still move their fair share of the load. Number 11 also stands ready at the Lanett yard, judging by the coal piled high in the tender.

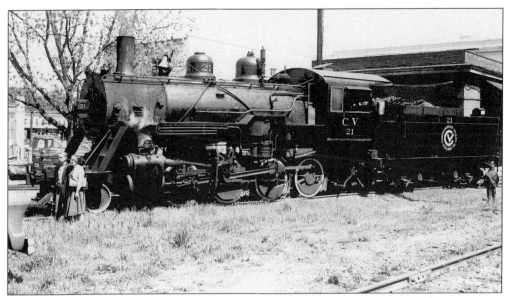

Remembered best is CV's #21. That is because the short-line kept it running and in service up to 1961, 14 years beyond the retirement of all other CV steam locomotives. Seen here in August of 1961 at West Point, the locomotive is the main feature of a special excursion just arriving from Atlanta on the A & WP mainline. After this day, #21 would be owned by the Atlanta National Railway Historical Society, having been donated by the CV. A couple poses in front of this beloved dinosaur before it departs for the last time.

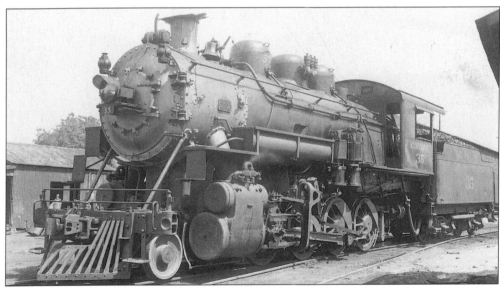

Need more pulling power for those hills? Number 35 was a 2-8-0 acquired in August 1939. Built by the American Locomotive Works Company (ALCO) in September of 1923, it was sold by the CV in 1947. When this iron horse was moving along with a string of boxcars in tow, it was a much better idea to stay out of its way, crossing the tracks after it went by.

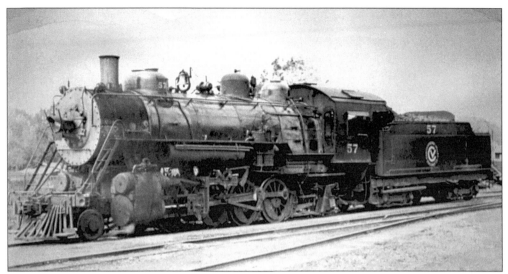

Another workhorse with the same wheel arrangement was built by Baldwin in October 1914. The CV bought #57 from the Atlanta, Birmingham, and Coast (originally the A, B & A) in April 1941. The CV connected with the A, B, & C at Standing Rock. Number 57 was sold in November 1947, leaving #21 as the last representative of the steam era on the CV.

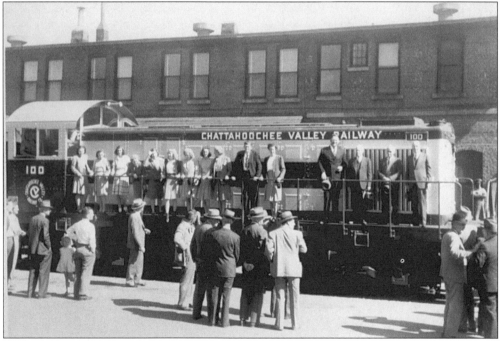

Everyone in town stops to take a look at a major technology change known as a diesel electric locomotive. This is an ALCO S-2, bought new by the CV in October 1946. The "S" stands for switcher. Diesels were designated by alphanumeric symbol and horsepower rather than wheel arrangement. Number 100 was staged on CV tracks that were in the streets of West Point. Other than the control cab, where the round roof is, it does not look anything like its predecessor. Diesel locomotives burn fuel oil to create electricity that powers the wheels. Vast amounts of water to create steam were not required.

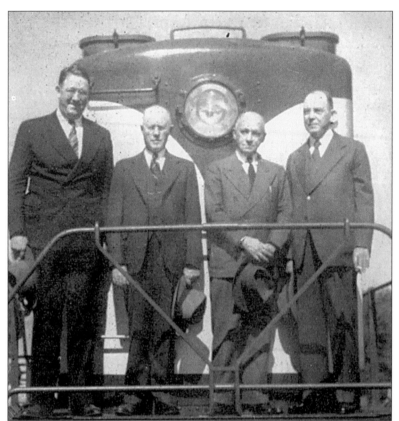

Standing to the left on the front of CV's new #100 is R.J. Morton, CV president and general manager. Next is S.R. Young, president, and G.E. Bolineau, traffic manager, both of the A & WP. George H. Lanier, well-respected president of the West Point Manufacturing Company, joins the occasion.

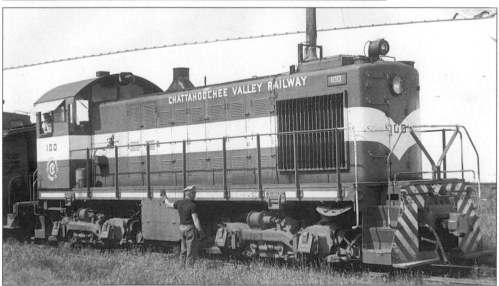

It is 20 years later here as #100 is in the yard with a caboose in tow. The brakeman on the ground is giving a hand signal to the engineer, a silent visual communication system used by railroads for decades. Each hand or arm motion has a different meaning, indicating direction of travel desired, speeds, and stop and go. Paying full attention was necessary; horseplay was not tolerated. Injury and damaged shipments were not desirable.

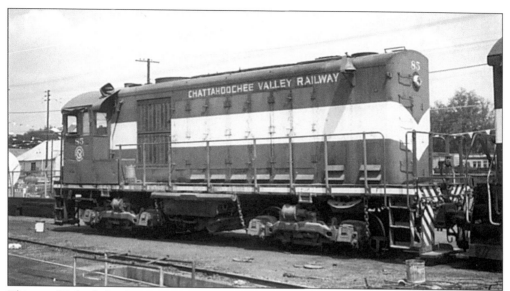

This is #85, built by ALCO in 1937. It has an unusual shape and was designated HH-900, representing the horsepower. It was bought well used in April 1961 from the Birmingham Southern Railroad. The CV employed this antique until October 1966, when #85 was traded in for new locomotive #101.

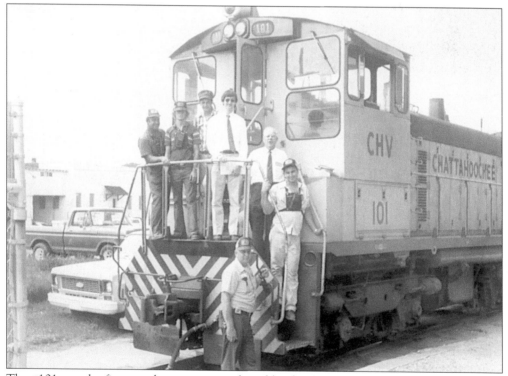

The #101 was the first new locomotive purchased by the CV in almost 20 years. September of 1966 finds this brand new Electromotive Division (EMD) switcher, rated for 1500 horsepower, with employees tiered on its steps. Pictured fourth from the left is Gordon Neil, who became president of the CV in 1966. He joined the CV in 1934 and retired in 1986.

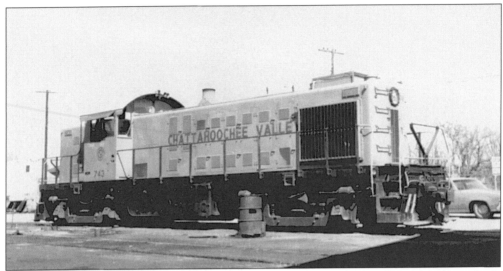

This is #743, built in 1941, at rest in the shop yard area. It was an ALCO RS-1 (road/switcher), so designated by its builder as useable for switching service or for distance hauling on the mainline (road.) The CV's practice of locomotive numbering kept the number that used locomotives came with. Number 743 was purchased in October 1968 and was sold to Birmingham Southern in 1973.

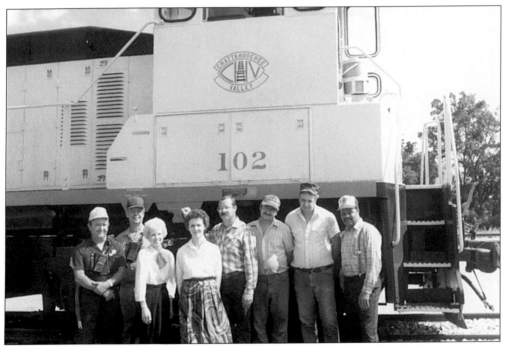

Company employees gather around EMD SW1000 #102. This diesel joined the CV roster in June 1988. It was bought to replace #100, which was sold the following year in August. Pictured fourth from the left is Kathleen Shaddix, who served as president and general manager of the CV from 1986 to 1991. She began in 1945 as a CV switchboard operator when the railway had its own telephone system.

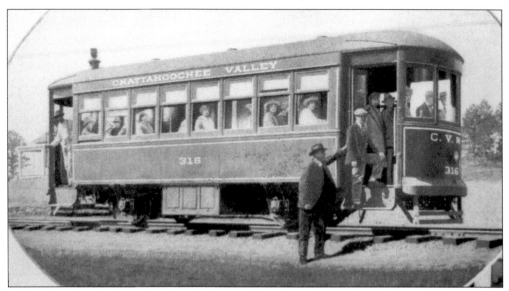

Two electric busses, such as #316 in this image, provided people a way to get back and forth through Valley and to West Point for 5¢. Electricity from a storage battery, similar to your car, provided power but required recharging between runs. This "bus" operated on the tracks. It was 32 feet 9 inches long. The CV numbered it 316, since it was purchased March 1916. One year later, #317 was numbered using the same reasoning.

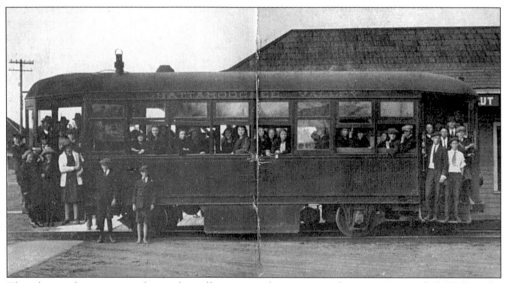

The electric busses were obviously well patronized, as seen in this image stenciled "Off to the Bank." It must have been payday. A close head count reveals at least 55 people on board. With any luck, the bank had enough money on hand to cash all those paychecks!

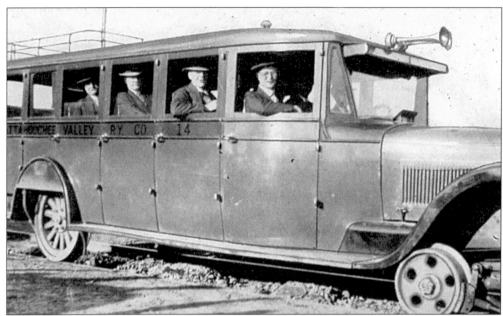

In the mid-1920s, the CV purchased a Studebaker automobile from the Kyle Motor Company of West Point. The railway then installed steel wheels, allowing the vehicle to ride on the tracks. Referred to as the jitney, a common nickname for conventional shuttle service, it did not remain long in passenger service, likely due to its limited seating. Railway officials, four shown here, kept this comfortable vehicle to inspect the railroad.

A 1921 full view of #14 highlights the special railroad wheels attached to the front. Just like trains, it was not necessary for the driver to steer. The rails and the flanges on the wheels performed that function. All the driver did was make it stop and go. To get out of the way of a train, switches anywhere along the mainline allowed the vehicle to pull into a sidetrack or a passing track.

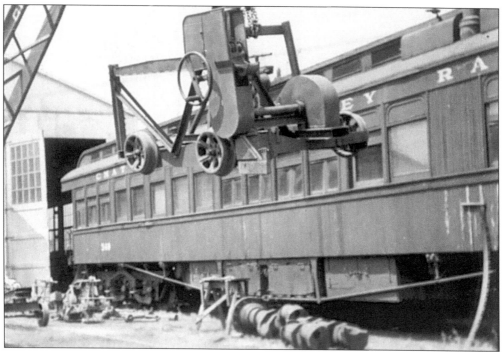

The CV had two "office cars" used by railroad officials for business or special excursions. Number 349 is seen by the shop in Lanett as a crane operator lifts up a piece of track maintenance equipment to load it onto a rail car. The #349 was purchased from the Louisville and Nashville Railroad in 1952. It had a kitchen, dining room, bedroom, and meeting area. It was purchased used and cost $3,437.06. The CV sold it in 1956.

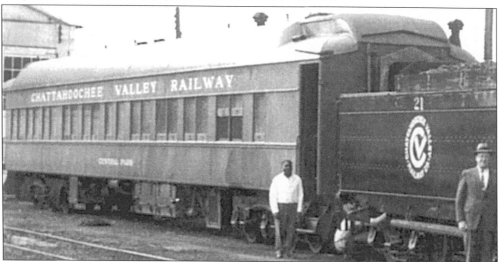

The other official's car was the Central Park, built in 1925, a former New York Central Railroad Pullman car used on the Twentieth Century Limited. CV records show it was purchased from the Pullman Company for $5,551.24 in January 1956 and sold in 1966. Equipment on board the #349 was salvaged and reused inside the Central Park. Here, the office car is coupled to the #21 in 1961, all cleaned and ready for a final excursion through Valley. Mr. Gordon Neil, right, stands proudly in front of this last CV passenger train.

A group of executives gathers around the back of the #349. Managers from the CV, A & WP, W of A, and C of G met often to inspect each other's facilities and discuss tariff and interchange issues. The CV depended upon timely interchanges of freight in rail cars. Inbound cotton was needed to keep everyone associated with the textile mills working. Outbound products required fast movement to keep good cash flow. Notables shown here at ground level are Arch Avary Jr. (third from left), Gordon Neil (fifth from right), Joe Lanier (seventh from right), and R.J. Morton, president of the CV (top-center).

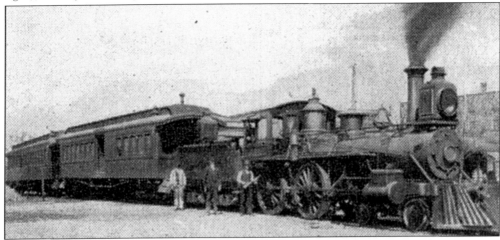

Rare are images of the initial CV passenger trains. This one comes from a 1901 brochure touting all that Valley, Alabama, has to offer. Among the many fine homes, churches, businesses, and recreational areas, there was the CV. The three-man crew stands ready in front of one of the 4-4-0 locomotives, a combine, and a coach. The engineer leans out of the locomotive for the photograph; however, judging by the smoke coming out of the stack, he has got it fired up and ready to go!

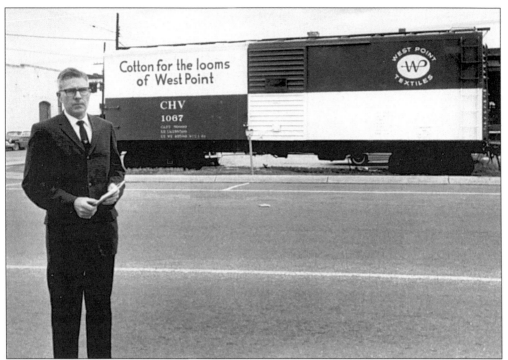

Boxcars were the main revenue producers of the CV, and the most visible. Making the most of these moving billboards, in 1961 CV boxcars were painted in an attractive blue and white scheme. It mimicked the graphic design being used by parent West Point Manufacturing for itself, designed by Raymond Lowery. Twenty 40-foot-long boxcars, like the one seen here, wore a West Point Textiles oval with letters "WP," represented by a weaving thread. To the left, "Cotton for the Looms of West Point" appeared over the car initials and number. This is CHV 1067.

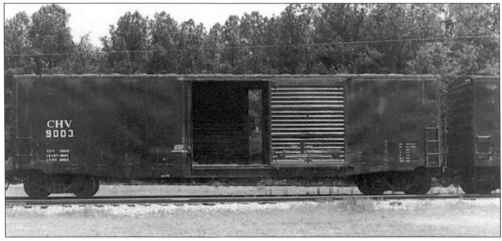

When older 40-foot boxcars began to wear beyond repairing, the CV purchased used 50-foot boxcars from neighboring railroads or private freight car rebuilding companies. Painted in basic black during leaner times, the CHV 9003 could carry a 140,000-pound load. It was purchased in 1983 from the SBD railroad; it is a former Seaboard Coast Line boxcar. Railroads began using longer cars in the 1960s to carry more and reduce wear and tear.

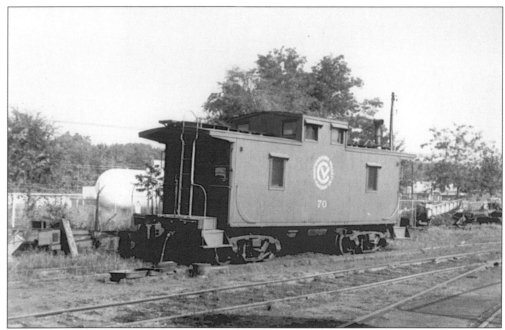

Cabooses were once a signature component of railroads, found at the end of every freight train. They provided an office on wheels for conductors and brakeman to keep up with car delivery paperwork and ride safely between drop off points. CHV 70 was a wooden caboose that served well and long. It was purchased in 1937and was retired in 1968.

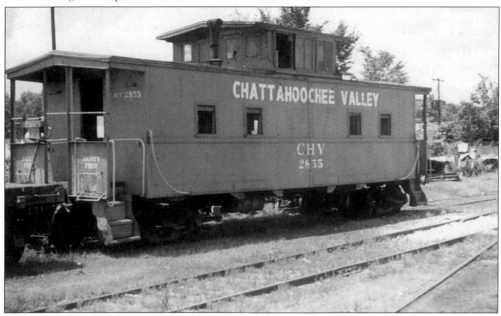

This steel caboose, CHV 2855, came from the Georgia Railroad (its #2855) in 1968. The CV was still in the practice of using the same number that equipment had come with 40 years later. Its sturdy construction allowed it to be pushed from behind by another locomotive, assisting loaded trains up grades. This caboose was sold in 1977, and it is believed to be still in existence near Salem, Alabama.

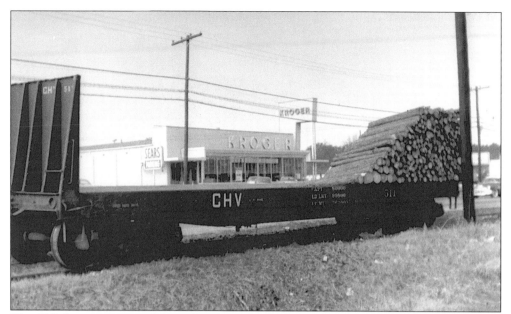

The CV's business was good enough to have the short-line convert 39 boxcars into wood pulp cars. CHV 511 is one such car, seen partially loaded setting on a sidetrack along highway 29 by Kroger Store and Sears. These cars were 40 feet long and could handle 100,000 pounds of cut wood. Local woodcutters pulled up alongside the cars and manually transferred the logs from truck to train.

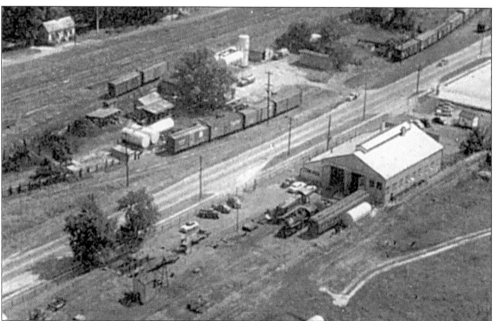

The CV's equipment required maintenance and repair. This is an aerial view of the CV's engine house, shop, and yard in Lanett where CV mechanics performed equipment maintenance. The metal building in the center right provided tools and machines for making repairs. The road running through this image is Highway 29, known as Jefferson Davis Highway. The A & WP yard is in the center left, with Davidson's Coal Company obscured by the tree.

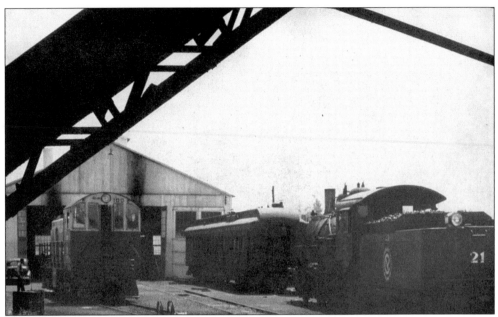

This is a 1954 scene viewed from the front entrance of the shop. A mechanic is inspecting #100. Office car #349 and locomotive #21, loaded with coal, share a shop track with little to do on this day. The object to the upper left is the arm of a conveyor belt used to load coal into tenders.

A broader view taken near the front gate shows the outline of the shop building, an all-corrugated metal structure with little architectural design. Locomotive #100 is in a blue drab paint scheme. Office car Central Park sits on the same track as the #349 did for the few years the CV owned it.

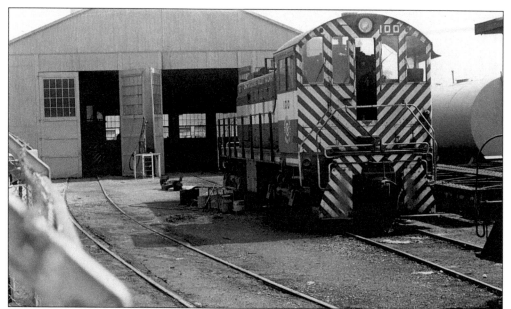

Everyone must be at lunch. There are tools on the ground next to #100, indicating minor maintenance work in progress. The dazzling stripes on the front of the locomotive were widely known as zebra stripes. The object of this eye-catching design was to increase safety at grade crossings by allowing impatient motorists every opportunity to see the train coming. It was not possible to stop a loaded train on a dime to avoid hitting automobiles.

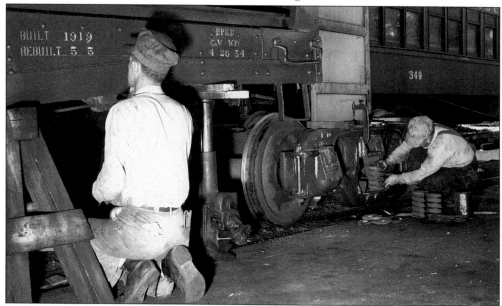

This is a close up of mechanics at work. These are the people who ritually inspected, repaired, and maintained the equipment, so it would not breakdown out on the "road," a costly and time-consuming nuisance on a busy single-tracked railroad. Here, Clay Collier, left, is applying pertinent information on one of the freshly painted woodpulp cars, a former boxcar built in 1919. Ray Kennon replaces a coil spring in the wheel assembly, known as "trucks." Behind Ray is #349 with its fancy window sashes.

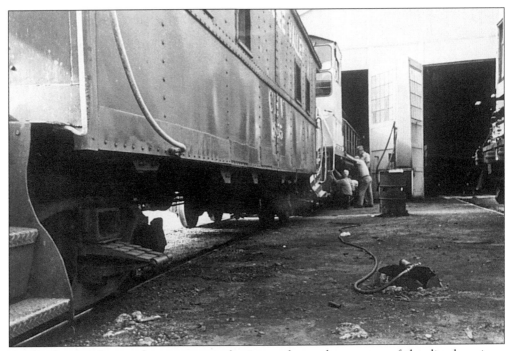

At the shops in Lanett, four unsung mechanics work together on one of the diesel engines. Caboose #2855 in the foreground came along for the ride to wait out what appears to be a small repair job.

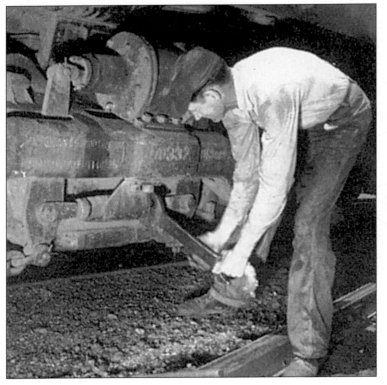

An example of a small repair is adjusting the brakes of a locomotive. However, do not underestimate the effort required to do such a task. Here R.A. Brown, a CV machinist, uses a two-foot-long special wrench to adjust the slack in a brake hanger on a truck attached to #100. It will not take long, but it needs to be right. Just like in a pit stop, locomotives were in and out quite fast!

Two

BUSINESS IN THE TWIN CITIES

The Chattahoochee River bordered the "Twin Cities" (a nickname given to West Point, Georgia, and Lanett, Alabama, as early as 1901) and occasionally engulfed their streets during floods. The CV had headquarters and shops first in Lanett and finally West Point, also the home of West Point Manufacturing Headquarters. Local businesses were served by CV tracks embedded in the streets. The two states lines skewed across CV tracks and Highway 29, resulting in CV operations crossing the boundary numerous times per day. The CV extended to Lanett in 1895 during its first year of operation and, realizing the need to extend northward, entered West Point, only a few feet away, during the 1900 reorganization that allowed it to build into Georgia. Trains trundled daily through the Twin Cities, providing passenger and freight service to and from the growing textile towns.

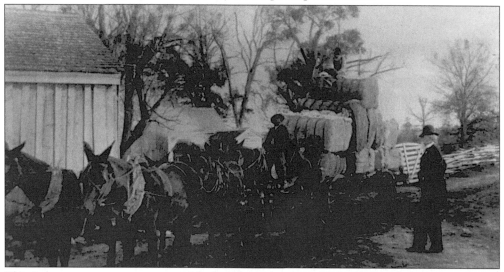

This is how cotton was transported before the railway was built. Cotton bales are stacked as high as possible on a wooden carriage. A team of six will make their best effort to get this crop to its destination. It is easy to imagine the added difficulty encountered when dirt roads turned to mud. Barges on the river worked for a while; the building of a railroad was the key to success for the textile company.

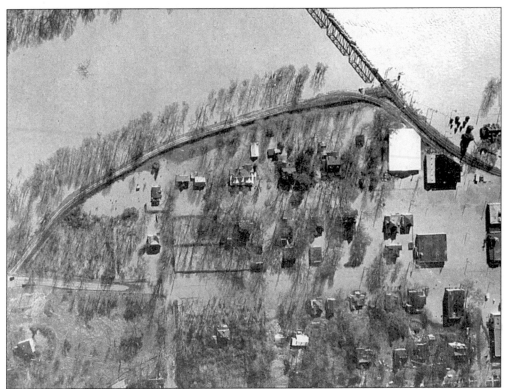

This is an aerial view of flooded West Point in 1961. This all-too-common event, which shut down activity and created losses, led to the construction of a dam just north of here. The bridge that crosses the river is that of the A & WP. The line that follows the riverbank is the CV's mainline northward to T.J. Beall's.

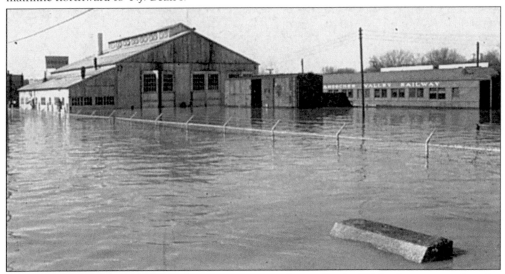

Like everything else, the CV shut down its operation during floods. With advance warning, the locomotives were taken to higher ground to keep their sensitive electrically driven wheels out of high water. The cars in this picture will be all right with minor attention. The stone monument in the foreground is about 3 feet tall, indicating the water is about 30 inches deep.

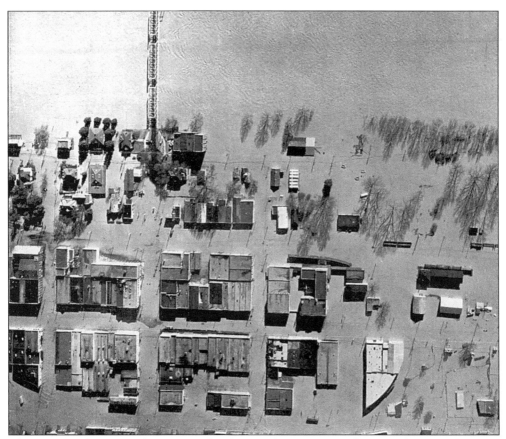

This view is adjacent to the previous flood view of West Point. The entire business district is flooded. The bridge at the top is Highway 18. The CV shop and yard are located in the lower right-hand corner near the wedge-shaped building. The state border passes near this building, once the West Point Warehouse Grocery.

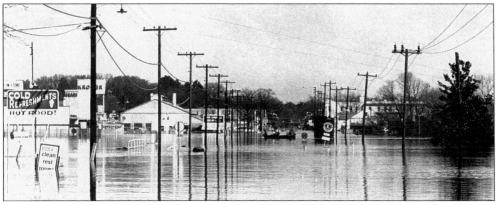

A ground level view looking north on Highway 29 provides the best perspective of the impact floods created. Men in a rowboat paddle down the highway, likely helping others in need. A Lions Club street sign is in front of a CV boxcar. The A & WP yard is to the right beyond the evergreen tree. The back of the CV shop can be seen to the left. Floodwaters often stayed two or more days.

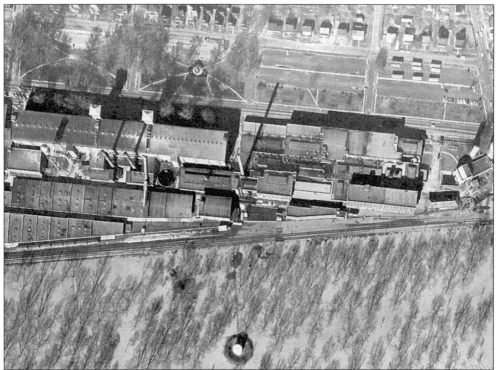

This is the West Point Manufacturing Company's Lanett Dye and Bleachery complex, which is adjacent to the location of the previous aerial image. The water is not as high here, reaching only the lower left area. An uphill grade for the original CV mainline began here, creating a 2.2% grade to pass over the W of A. The CV's mainline originally passed in front of this mill complex. In 1938 it was relocated, passing through the complex from the back (top of image).

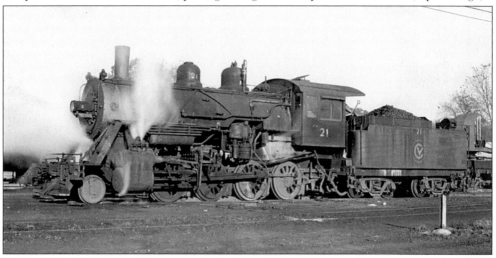

Steam locomotives served the CV well. They also provided a social aspect. Whether at rest, such as #21 here, or chugging away up a hill with heavy tonnage in tow, their visible moving parts, hissing steam, and smokestack displays created a show for many. Neighbors along the tracks and children in waiting automobiles stared intently as the Buck Rogers–era iron horse's action etched indelible memories in their minds.

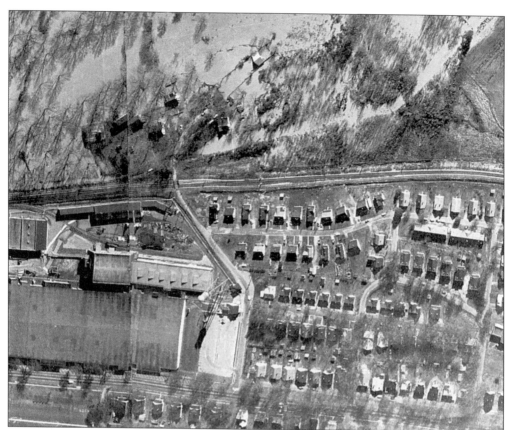

A continuation aerial of the Lanett Dye and Bleachery and residential area shows its rising terrain area above floodwaters. Obviously, many employees could walk to work. The 1938 relocated mainline squeezed through the complex near the center left portion of the image, then passed through the residential section. During the 1955 Highway 29 widening project, the CV relocated again, following the W of A tracks that splice through the center of this image.

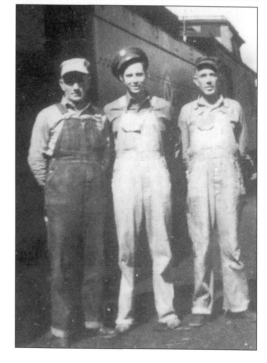

Bill Cooper provided this image of the McCoys, a well-known name within the CV. Standing next to #21 and a wooden caboose are, from left to right, as follows: engineer Claude B., fireman Pete C., Claude's son, and master mechanic M. Paul McCoy. Bill's grandfather (not shown) was M.C. McCoy, who worked for the A & WP.

Steam locomotives required coal for their fires to boil water to make steam. Coal was America's mainstay fuel until oil entered the scene. Transporting, handling, and storing coal was a deficit-producing task the CV, like all railroads, had to deal with. Handling coal and cinder ash residue was a laborious chore, as seen here. The apparatus to the left is a coal conveyor belt that carried coal upward from ground level, dumping it into the top of coal tenders.

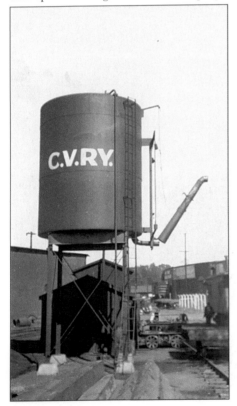

Steam locomotives used water by the hundreds of gallons. On short runs, the locomotive and tender might be able to carry enough to make the round trip. If not, the railroad had to locate water towers strategically along the right of way where trains could stop to replenish. This steel water tower was located in the shop area in Lanett. It remained useful as long as steam locomotives were still around. A water tower in the Powledge area is believed to be still standing, albeit covered with kudzu, a climbing vine-like vegetation.

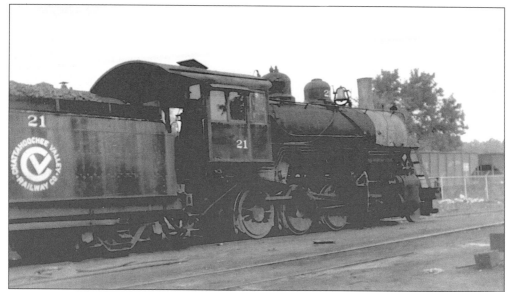

Most railroads had converted to all diesel power by the late 1950s. For whatever reason, the CV kept #21, and everyone was grateful. A speculated reason, besides nostalgia, is that steam locomotives could travel through higher floodwater than diesels. Nonetheless, here it sits loaded with coal without a fire burning. Any memorable image a fully operating steam locomotive created was reversed when one sat quietly without a wisp of steam to be seen.

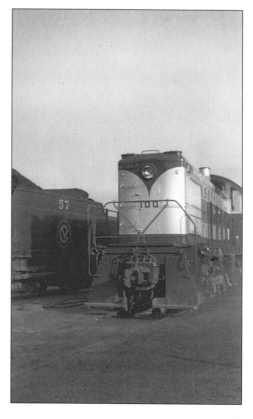

The "new kid" on the block, #100, is parked next to #21, the "old kid." From 1947 to 1961, they worked together allowing the CV to keep up the business. Occasionally, these two contrasting machines would couple, known as double heading, to provide excursions for boys scouts and other groups. CV management was always willing to contribute to the welfare of the community in the same spirit as parent West Point Manufacturing.

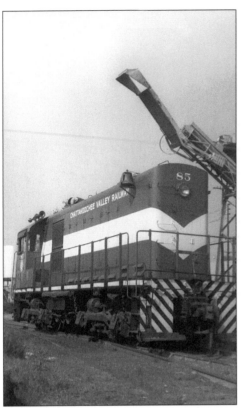

Parked under the coaling chute, #85 is in a position to receive coal it does not need. This interesting unit, from an early technology perspective, was a pioneer of its time. The first successful application of a railroad diesel engine was in 1925. Number 85 was new in 1937, when larger steam locomotives were still being built. Selling the diesel concept to railroads did not happen until the late 1940s.

Before 1974, it was necessary for CV trains leaving the shop to cross Highway 29 at the beginning and end of the day. The tracks here curve northward, leading to North West Point and T.J. Beall's. The building is that of the A & WP, used by its train crews and freight agents in later years. Highway 29 is in the foreground.

In 1974, the CV leased the A & WP building, consolidating management and shops in the same facility for the first time. An extension was added to allow for locomotive maintenance work. The CV could now abandon its Lanett shop and yard tracks, saving considerable costs. The A & WP was being absorbed into a larger railroad company and no longer needed intermediate facilities such as this.

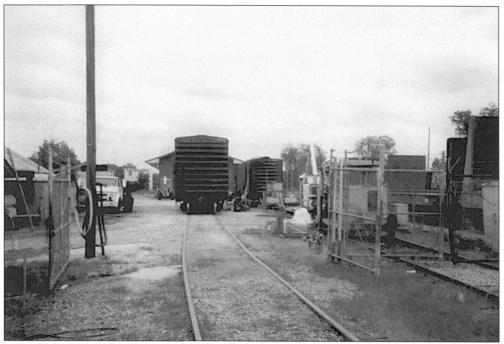

Fair weather allowed much car repair work to be done outside. This view was taken from the gate of the CV's new shop and yard. A CHV boxcar that just arrived from River Dale mill was having its wheel journals repaired. Maintenance equipment was stored to the left and right sides of the yard.

Brakeman Randall Moody uses a company telephone to get orders from the main office. CV trains were dispatched on record to ensure that, despite its small size, everyone knew where the trains were. Some trains made several stops along the line, picking up and dropping off cars at various locations. While doing so, the remainder of that train could not be left on the mainline, if another train was due to pass. The CV once had an automatic signal system on its mainline to protect trains from collisions.

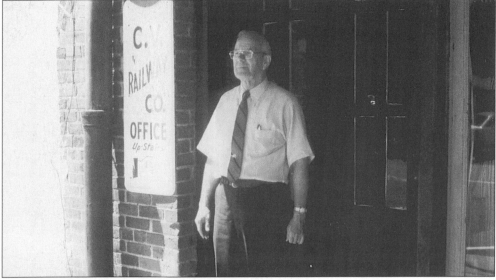

One of the best remembered CV management headquarters was on the second floor of the Zachry Brothers building, an early 1900 structure built by LaFayette Lanier. It was located on the corner of West Eighth Street and Fourth Avenue. Gordon Neil, CV superintendent from 1948 to 1963, steps out on a bright sunny day that has almost obliterated the CV Railway sign with the soft drink ad on top. Of course, Coca-Cola was the most popular drink in these parts.

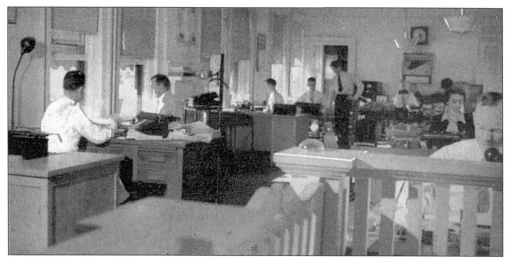

Behind the scenes of the omnipresent CV trains was a dedicated group of employees working at the railway's office. Processing waybills, tariffs, payroll, receipts, and correspondence, these employees were as important as those moving boxcars. In this 1940 scene are the following, from left to right: Charlie Veazey, Gaines Lancaster, John Samples, Sam Bray, Kenon Foster, Barney Curley (under clock), Carolyn McKemie, and Lee Swint on the telephone.

Here are Ray Swann, Lee Swint, and Gerry Meacham in 1960, looking over a collection of coins that remained on top of a stairway post for years. It seems each of these coins has a history dating to 1937, starting with a single penny. Visitors added to, and occasionally subtracted from, the collection that grew to almost 50 coins. Gerry Meacham became agent treasurer of the CV and one of the friendly faces that greeted visitors up to the CV's last day.

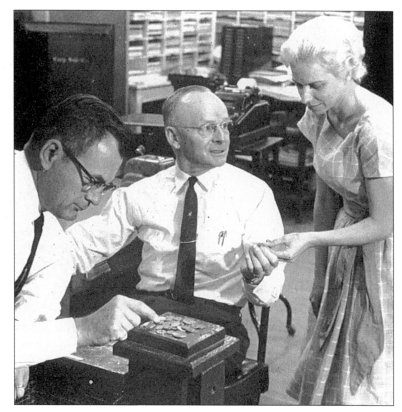

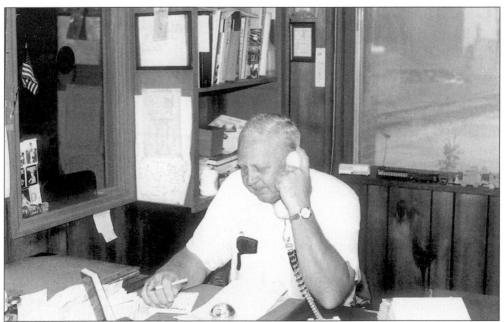

Leroy Pigg is on the telephone in the main office in the A & WP building. He is checking on car locations and anticipated delivery times at the yard. Mr. Pigg came up through the ranks with CV, serving in mechanical and transportation positions. He was there to the last day and capable of handling any aspect of the operation. He stayed on to supervise a contractor hired to dismantle the short-line. Mr. Pigg typified the friendly spirit of CV employees.

Visitors came from near and far. The CV even had souvenir passes to accommodate visitors. James and Janet Gallo, from New Jersey, and their Uncle Joe Nabors, stopped to see the CV, as rumors of its demise grow stronger. Joe Nabors, familiar to many in the area, worked at Merritt Electric and Furniture store for many years. His wife, Joyce, is a long-time employee of West Point Stevens.

After seeing the equipment and meeting some people, now it is time to get to work! This crew is ready to step on board #100 at the Lanett shop area. Permission from the dispatcher received, orders in hand, it is time to move some cars and make some money for the company.

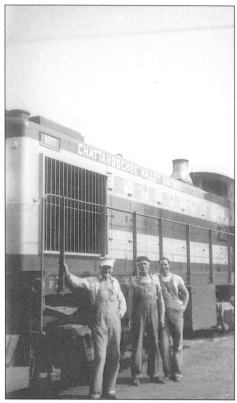

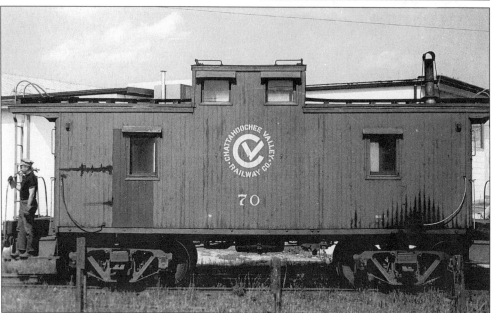

Built in 1937, #70 is a wooden antique, looking quaint but not attractive in 1966. It is still functional and wears the original style CV logo. Baynard Dabbs rides the lower step of the caboose, keeping an eye out to make sure the way is clear, since the engineer cannot always see when backing up.

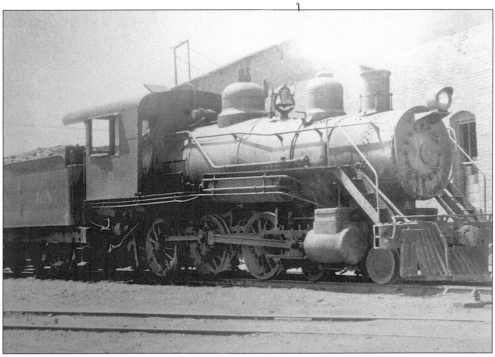

Bill Cooper provided this image of #9, which is prepared for a day's work judging by the coal piled high in the tender. These locomotives were hot to work in most of the year, considering Georgia's average warm temperature.

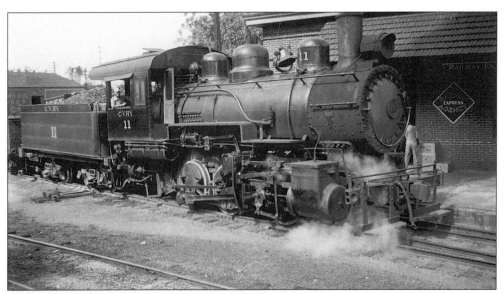

Switcher locomotives, like #11, worked around the yard and in areas where slow speeds were required. It is switching cars in the yard near the front of the A & WP's passenger depot. A Railway Express Company sign can be seen on the building. Number 11 was sold in 1941 to the Raritan River Railroad in New Jersey, becoming that railroad's second locomotive numbered seven. It was scrapped in 1947.

Numbers 85 and 100 are coupled and set up for a good day's work near the Cherry Street crossing. The building in the center of the image is Huguley Scott Used Cars, in front of the A & WP freight building. This is the state borderline area the CV crossed frequently.

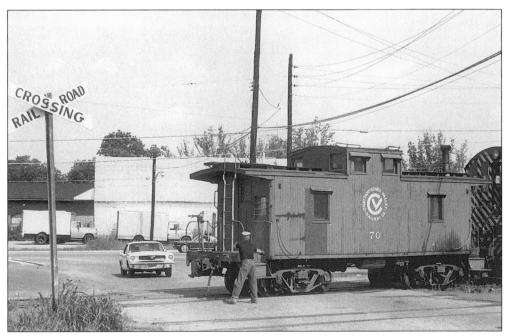

Larry Goolsby contributed a great selection of CV photographs, taken when the carrier was still very busy. A Ford Mustang waits while brakeman Baynard Dabbs ensures all traffic is stopped before he steps onto the caboose at this busy, and getting busier, grade crossing.

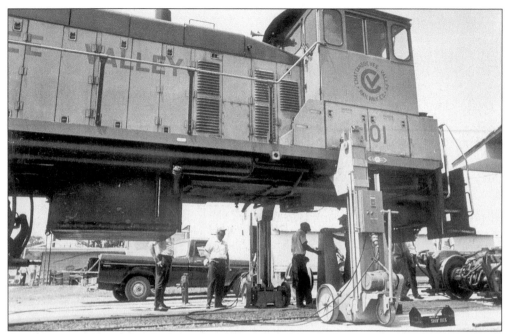

Once the crews departed with their trains, the real work began. Locomotive trucks, the powered wheels, required work that could not be done with the locomotive body sitting upon them. So, up it goes on jack-stands capable of safely lifting 130 tons in a few minutes. Injuries and mishaps on the CV were a rarity due to the careful habits of its employees.

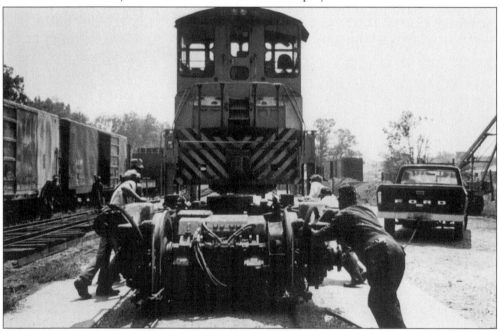

Once repaired, everyone pitched in to roll the truck out of the shop and back under the locomotive. Five men push the heavy but free rolling truck out of the A & WP shop after making repairs. The weight of the locomotive holds itself onto the fitted designs on trucks. Electrical cables will be reconnected to the controls.

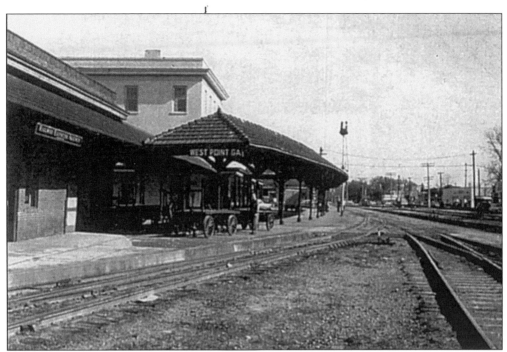

Leaving the yard heading north, CV crews passed the A & WP's passenger depot. This depot provided a stopping point for local West Point Route trains serving between Atlanta and Montgomery. The most famous passenger train stopping here was the Crescent. Pulled by the Pennsylvania Railroad from New York City, this full-accommodation train was handed over to the Southern Railway in Washington, D.C. At Atlanta, the WPR took over to Montgomery. The Louisville and Nashville finished the run to New Orleans.

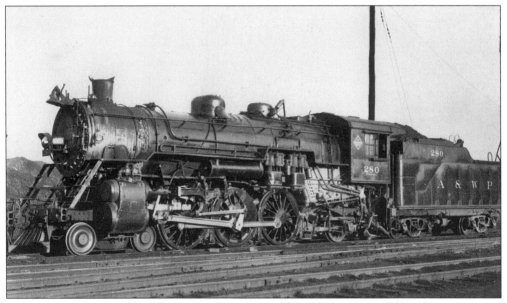

Either A & WP or W of A locomotives were assigned to the Crescent and local service trains. A & WP #280, a Pacific type, is one of the fleet that was depended upon. J.R. Quinn took this image while #280 was in good shape and loaded with coal, ready for the next assignment.

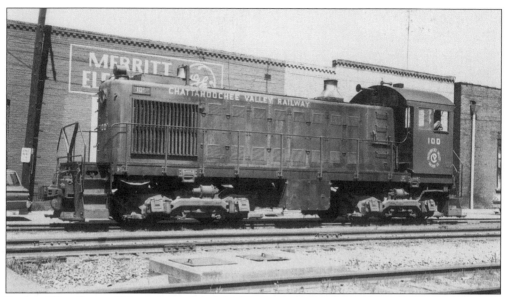

Back at West Point, CV trains paralleled the WPR mainline past the back of the main business district stores. Number 100 passes Merritt Electric and Furniture, an iconic establishment that served the West Point and Valley area until Mr. Merritt's passing.

This view is north. The CV used the track on the left to meander its way out of town and along the riverbank of the Chattahoochee River. The WPR mainline is to the right. It looks quiet now. When express WPR freight trains came along, all of West Point's traffic stopped as over 100-car trains block town for a few minutes, making a great rumble.

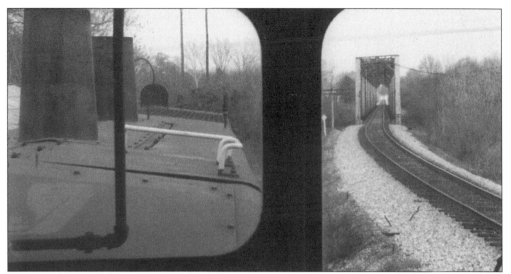

From the cab of a CV locomotive, this is a straight view through the WPR bridge northward over the Chattahoochee River. Fast freight trains come over this bridge at 35 miles per hour, a true sight to behold. The CV tracks swing to the left here, rated at a 10-miles-an-hour maximum speed.

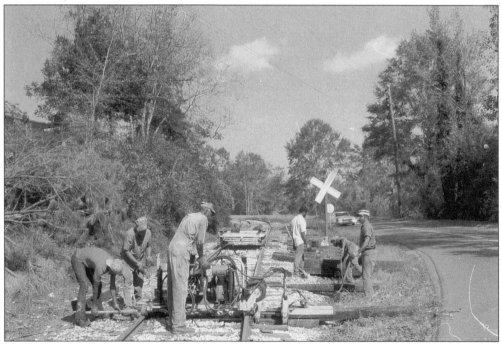

A section gang, which maintained tracks, is replacing ties at the Third Avenue crossing. The machine they are using extracts old ties and inserts new ones, saving a lot of back strain. Some of the CV's section men were James Martin, James Murphy, Dennis Bailey, Willie Joe Cochran, Walter Collins, and Clennon Hubbard. Dennis Lindsay served as track supervisor, while Joe Shaddix was superintendent of maintenance. (Not all are shown in this image.) This CV crossing, and others, would be improved through a Federal Safety program aimed at reducing grade crossing accidents.

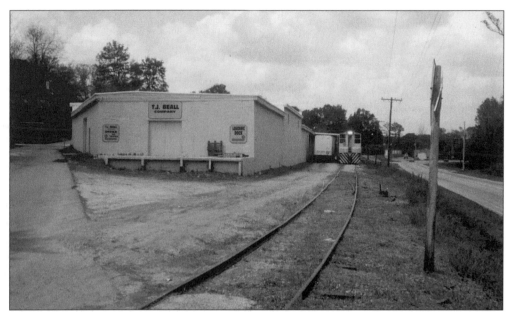

Along State Line Road is T.J. Beall's, a private company that utilized by-products from the textile company. T.J. Beall's made good use of cotton waste from the mills, one boxcar at a time. There were two buildings with sidings served by the CV. This one is the main headquarters and office. Notice a trailer parked at the loading dock next to the locomotive on the mainline, a sign of things to come.

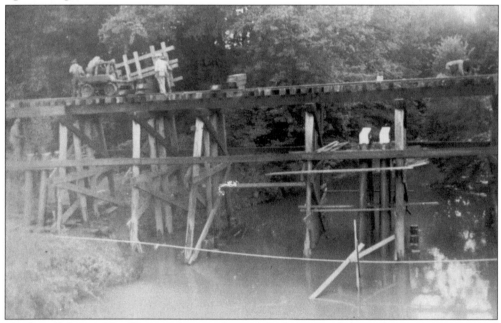

Northward, beyond Beall's, was this wooden trestle that carried the early CV steam-powered trains over the Oseligee Creek to Standing Rock. A section gang is making improvements to the structure, which will soon need to carry heavy trains up to the Army Corps of Engineer Project, a new Chattahoochee dam and power plant. Solely to support this project, from 1966 to 1973 the CV operated over a 2.8-mile extension from this bridge.

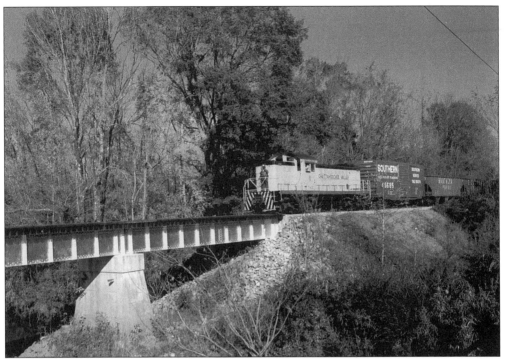

Here comes an empty CV train heading south for reloading. Look at the new steel span bridge over the Oseligee Creek. The CV played an essential role in the construction of the dam, hauling slag and aggregates by the trainload from Bleecker to North West Point. The boxcar behind the engine could be an idler, a car used to keep heavy locomotives off certain structures due to weight limits.

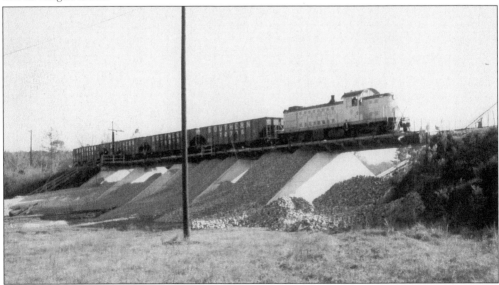

At the dam site, a special trestle allowed the contents of the open hoppers to fall through to the ground for pick up by bucket loaders. Hoppers had bottoms that opened for this purpose. There is no idler needed, as the cars are empty. CV #743 prepares to couple up to these four empties to clear the track for more loads.

CHATTAHOOCHEE VALLEY RAIL
ELECTRIC CAR AND PASSENGER T

Effective December 19, 1925

STATIONS	Miles	DAILY EXCEPT SATURDAY & SUNDAY					SATURDAY				
		No.8	No.10	No.12	No.14	No.18	No.8	No.34	No.12	No.14	No.16
Leave Standing Rock-Ala.	0	-----	-----	(x)	-----	(x)	-----	-----	(x)	-----	-----
' Oakland-------Ala.	6	-----	-----	-----	-----	-----	-----	-----	-----	-----	-----
' Adams--------Ala.	8	-----	-----	-----	-----	-----	-----	-----	-----	-----	-----
' Atkinson------Ala.	10	-----	-----	-----	-----	-----	-----	-----	-----	-----	-----
' Anderson------Ala.	12	-----	-----	-----	-----	-----	-----	-----	-----	-----	-----
Arrive West Point-----Ga.	17	-----	-----	-----	-----	-----	-----	-----	-----	-----	-----
		AM	AM	AM	PM	PM	AM	AM	AM	PM	PM
Leave West Point-----Ga.	17	6 00	8 00	10 25	1 10	5 10	6 00	8 20	10 25	12 45	2 15
' Lanett--------Ala.	18	6 05	8 05	10 30	1 15	5 15	6 05	8 25	10 30	12 50	2 20
' Shawmut-------Ala.	20	6 15	8 15	10 40	1 25	5 25	6 15	8 35	10 40	12 58	2 30
' Langdale------Ala.	22	6 25	8 25	10 50	1 35	5 35	6 25	8 45	10 50	1 05	2 40
' Fairfax-------Ala.	23	6 35	8 35	11 00	1 45	5 45	6 35	8 55	11 00	1 15	2 50
' Riverview-----Ala.	26	-----	-----	11 15	-----	6 00	6 50	-----	11 15	1 25	-----
' McGinty-------Ala.	27	-----	-----	-----	-----	-----	-----	-----	-----	-----	-----
' Blanton-------Ala.	31	-----	-----	-----	-----	-----	-----	-----	-----	-----	-----
' McCulloh------Ala.	33	-----	-----	-----	-----	-----	-----	-----	-----	-----	-----
' Halawaka------Ala.	38	-----	-----	-----	-----	-----	-----	-----	-----	-----	-----
' Powledge------Ala.	41	-----	-----	-----	-----	-----	-----	-----	-----	-----	-----
Arrive Bleecker------Ala.	45	-----	-----	-----	-----	-----	-----	-----	-----	-----	-----

STATIONS	Miles	No.9	No.11	No.13	No.15	No.19	No.9	No.35	No.13	No.15	No.17
Leave Bleecker------Ala.	0	-----	-----	(x)	-----	(x)	-----	-----	(x)	-----	-----
' Powledge------Ala.	4	-----	-----	-----	-----	-----	-----	-----	-----	-----	-----
' Halawaka------Ala.	7	-----	-----	-----	-----	-----	-----	-----	-----	-----	-----
' McCulloh------Ala.	11	-----	-----	-----	-----	-----	-----	-----	-----	-----	-----
' Blanton-------Ala.	14	-----	-----	-----	-----	-----	-----	-----	-----	-----	-----
' McGinty-------Ala.	18	-----	-----	-----	-----	-----	-----	-----	-----	-----	-----
				AM		PM	AM		AM	PM	
' Riverview-----Ala.	19	-----	-----	11 15	-----	6 00	6 50	-----	11 15	1 25	-----
		AM	AM		PM			AM			PM
' Fairfax-------Ala.	22	7 05	8 35	11 30	1 45	6 15	7 05	8 55	11 30	1 35	2 50
' Langdale------Ala.	23	7 15	8 45	11 40	1 55	6 25	7 15	9 05	11 40	1 45	3 00
' Shawmut-------Ala.	25	7 25	8 55	11 50	2 05	6 35	7 25	9 15	11 50	1 52	3 10
' Lanett--------Ala.	27	7 35	9 05	12 00	2 15	6 45	7 35	9 25	12 00	2 00	3 20
Arrive West Point-----Ga.	28	7 40	9 10	12 05	2 20	6 50	7 40	9 30	12 05	2 05	3 25
Leave West Point-----Ga.	28	-----	-----	-----	-----	-----	-----	-----	-----	-----	-----
' Anderson------Ala.	33	-----	-----	-----	-----	-----	-----	-----	-----	-----	-----
' Atkinson------Ala.	35	-----	-----	-----	-----	-----	-----	-----	-----	-----	-----
' Adams---------Ala.	37	-----	-----	-----	-----	-----	-----	-----	-----	-----	-----
' Oakland-------Ala.	39	-----	-----	-----	-----	-----	-----	-----	-----	-----	-----
Arrive Standing Rock-Ala.	45	-----	-----	-----	-----	-----	-----	-----	-----	-----	-----

(x) - U.S. Mail handled on trains 12 & 13 - 18 & 19 - 28 & 29.

C. E. WRIGHT,
General Manager.

	No.20	No.4	No.6	No.26	No.28	No.30	No.32	No.4	No.6
				SUNDAY ONLY					
			PM						**PM**
	-----	-----	1 40	-----	(x)	-----	-----	-----	1 40
	-----	-----	2 00	-----	-----	-----	-----	-----	2 00
	-----	-----	2 08	-----	-----	-----	-----	-----	2 08
	-----	-----	2 12	-----	-----	-----	-----	-----	2 12
	-----	-----	2 17	-----	-----	-----	-----	-----	2 17
	-----	-----	2 32	-----	-----	-----	-----	-----	2 32
	PM	**AM**		**AM**	**AM**	**PM**	**PM**	**AM**	
	7 00	7 40	3 00	7 00	10 25	1 00	5 10	7 40	3 00
	7 05	7 45	3 05	7 05	10 30	1 05	5 15	7 45	3 05
	7 15	7 53	3 11	7 15	10 40	1 15	5 25	7 53	3 11
	7 25	7 59	3 17	7 25	10 50	1 25	5 35	7 59	3 17
	7 35	8 09	3 23	7 35	11 00	1 35	5 45	8 09	3 23
	-----	-----	-----	-----	11 15	-----	6 00	-----	-----
	-----	8 19	3 33	-----	-----	-----	-----	8 19	3 33
	-----	8 34	3 48	-----	-----	-----	-----	8 34	3 48
	-----	8 42	3 58	-----	-----	-----	-----	8 42	3 58
	-----	8 52	4 06	-----	-----	-----	-----	8 52	4 06
	-----	9 02	4 16	-----	-----	-----	-----	9 02	4 16
	-----	9 12	4 26	-----	-----	-----	-----	9 12	4 26

	No.21	No.5	No.7	No.27	No.29	No.31	No.33	No.5	No.7
		AM	**PM**					**AM**	**PM**
	-----	9 17	4 35	-----	(x)	-----	-----	9 17	4 35
	-----	9 27	4 45	-----	-----	-----	-----	9 27	4 45
	-----	9 37	4 55	-----	-----	-----	-----	9 37	4 55
	-----	9 47	5 03	-----	-----	-----	-----	9 47	5 03
	-----	9 55	5 13	-----	-----	-----	-----	9 55	5 13
	-----	10 10	5 18	-----	-----	-----	-----	10 10	5 18
					AM		**PM**		
	-----	-----	-----	-----	11 15	-----	6 00	-----	-----
	PM			**AM**		**PM**			
	7 35	10 20	5 28	7 35	11 30	1 35	6 15	10 20	5 28
	7 45	10 30	5 35	7 45	11 40	1 45	6 25	10 30	5 35
	7 55	10 36	5 41	7 55	11 50	1 55	6 35	10 36	5 41
	8 05	10 44	5 47	8 05	12 00	2 05	6 45	10 44	5 47
	8 10	10 49	6 00	8 10	12 05	2 10	6 50	10 49	6 00
	-----	10 59	-----	-----	-----	-----	-----	10 59	-----
	-----	11 14	-----	-----	-----	-----	-----	11 14	-----
	-----	11 19	-----	-----	-----	-----	-----	11 19	-----
	-----	11 23	-----	-----	-----	-----	-----	11 23	-----
	-----	11 31	-----	-----	-----	-----	-----	11 31	-----
	-----	11 53	-----	-----	-----	-----	-----	11 53	-----

T. EDMONDS,
 General Superintendent.

The CV believed it was necessary to have a connection with a third railroad in order to enjoy the best tariffs. An extension to Texas, Georgia, was authorized; however, the CV stopped at Standing Rock. This is a CV Public timetable showing electric car (rail bus) and passenger train schedules effective December 19, 1925. Notice that West Point and Fairfax had the most scheduled service. There were more trains operated Saturday than any other day, possibly to accommodate shopping in West Point. U.S. mail was handled on trains numbered 12, 13, 18, 19, 28, and 29, covering seven days a week.

Trains operating over the entire line, #5 and #6, ran on Saturday, and on Sunday, only #5 ran. Keep in mind that CV freight trains were operated between passenger train schedules. Passing sidings were installed on the CV's single-track mainline to allow freight trains to be in the clear when necessary. Fairfax had a passing track. Notice trains number 10 and 11, traveling in opposing directions, were both scheduled at Fairfax at 8:35 a.m. The rules stated that the first train to arrive at certain points was to wait for the second train, especially if it was late. Some trains turned at endpoints to become another train. For example, train #14 turned, becoming #15, etc.

51

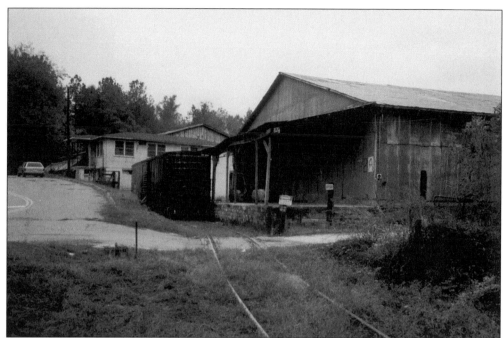

From 1973 until 1992, T.J. Beall's area marked the north end of CV tracks. The track from the bridge to the dam was abandoned and removed. The bridge fell into disrepair, with washouts exposing pier footings. It did not matter. The CV would never again need to cross the bridge. Here at Beall's Warehouse #2A, a 50-foot-long CHV boxcar is nestled at the loading dock. A close clearance sign lets brakeman hanging on the side of cars know there is no room for a man between the dock and the car.

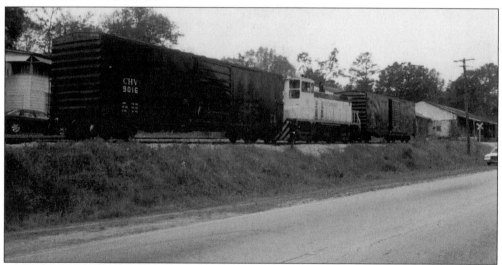

Arriving at Beall's generally meant that the arriving train must push a boxcar north, had it been left on the mainline for unloading. Here, the boxcar to the right is at Beall's (where the trailer is on page 48). Engine #102 has arrived with CHV #9016 in tow, which is to be delivered to the locking dock on the mainline. Brakeman Charles Cameron, visible by the back steps of #102, gets off to throw a switch while engineer Larry Wade moves the train northward (toward the right).

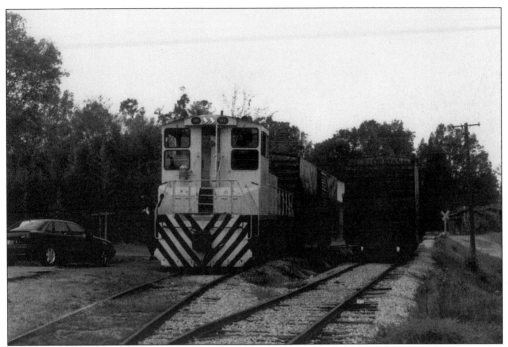

This is the runaround track at Beall's. It has switches at both ends and just enough room to pass, or runaround, a few boxcars. The CHV #9016 is to the right, having been uncoupled by brakeman Cameron. The #102 and the boxcar originally at Beall's now reverse direction back to West Point (southward, or to the left), passing standing CHV #9016.

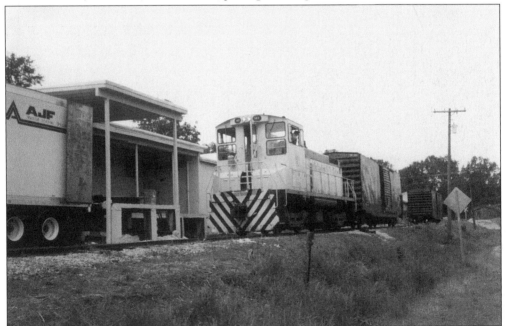

After the train passes the switch where Mr. Cameron was originally waiting, he lines that switch straight again, so the train can back up and couple to CHV #9016. There is the trailer at the loading dock noted earlier. The next move is to leave the CHV #9016 by the trailer.

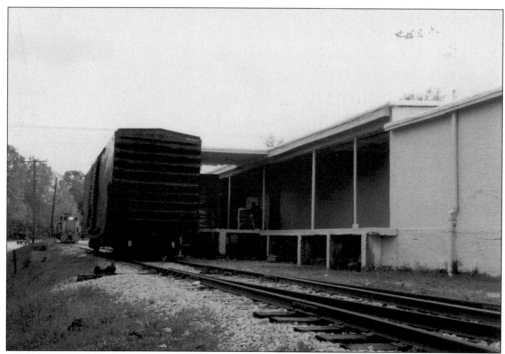

As the train heads south, Mr. Cameron uncouples CHV #9016 at the dock, sets the brake so it does not roll away, and gets back on the train for the ride back to West Point. Short-line train crews often have to switch and runaround numerous cars in the course of the day. Before your train leaves the yard, it is important to have certain groups of cars located in the train at specific points to make the day go more efficiently and safely.

Arriving back in town, the view is southward with the A & WP mainline (left) and the CV and A & WP joint-use track (right). A pedestrian footpath is visible crossing both tracks.

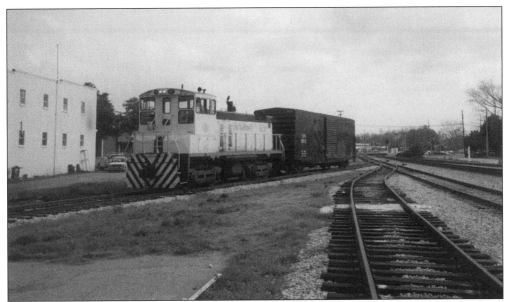

Pulling into the yard at the site of the former A & WP depot is the train from Beall's. The boxcar will stay with the train, since it is not done for the day. Now it is time to make up a train and head south to the mills, located in Valley. The cars delivered by the WPR are in the joint yard. The CV crew will have to move other cars around to get all they need on a single track.

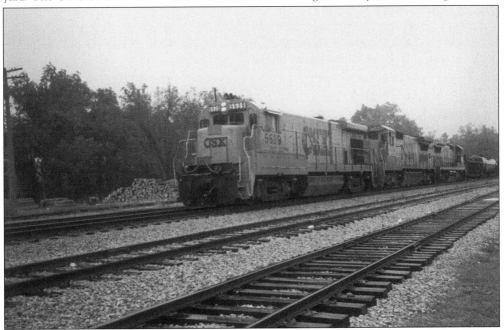

The WPR mainline was, and is still, a busy freight corridor. The Crescent was rerouted off the WPR through Birmingham in 1969, and the WPR's local passenger trains had by then ceased giving freights the domain. As railroad merger mania took place throughout the nation in the 1970s, the WPR was absorbed, losing its identity. On this day, CSX owns the line through West Point. This view shows three CSX diesel locomotives with a train, with more than 100 cars, passing through. Cars for the CV are brought by a local CSX freight train.

This image of the A & WP yard shows CV's new connecting track with fresh ballast and the 1955 Highway 29 widening project underway to the right. The telephone poles have been moved towards the track, as a result of a four-lane highway through the Twin Cities. The CV shop is still across the highway in Lanett.

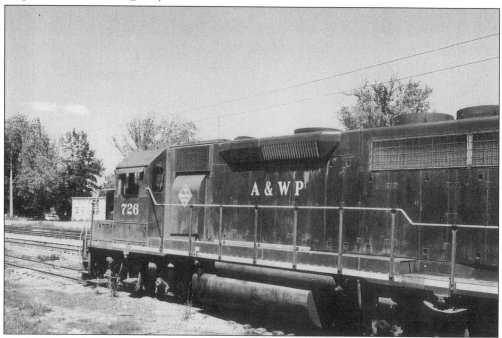

A & WP's #726 is pulling into the yard to make a local delivery. Besides the CV, the A & WP had a decent local business, which included wood pulp, various materials for the new Huguley Industrial Complex, and woodchips. The CV and A & WP also tried trailers-on-flatcars, known as piggybacks.

The CV crew is in the yard coupling up cars destined for the mills. Clear communications by sight, hand signals, and two-way radio was important when men were working between steel railroad cars. There was no room for error or misjudgments.

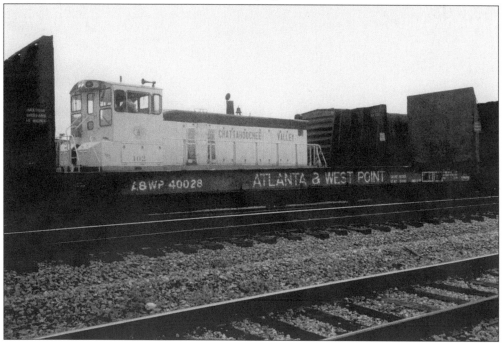

The #102 looks like it is buried amongst the crowded yard of rail cars. Here it is under framed by A & WP pulpwood car #40028. Engineer Larry Wade is in the cab paying full attention to the crew members on the ground giving him signals to move forward and backward.

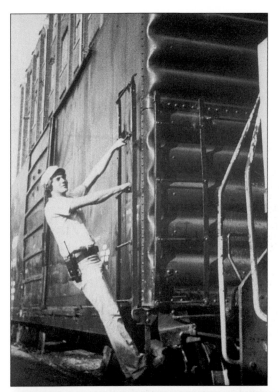

Normally, train crews would walk back to the engines during switching. However, for times when this was too time-consuming, freight cars are equipped with ladders, grab bars, and stirrup-type steps for train crews to hold on to. Randall Moody holds on to a CHV boxcar that is being towed by an engine. Notice his two-way radio safely inside the holster clipped onto his belt. The CV purchased its first radio in 1946 with the #100. Radios reduced the number of men required to pass hand signals along lengthy trains.

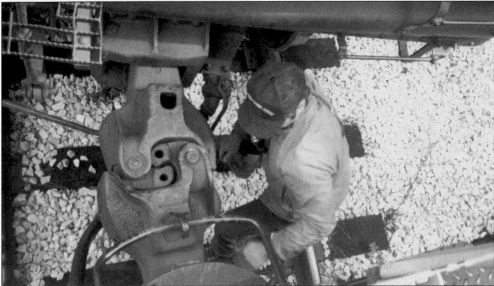

This bird's-eye view of the coupling process gives an idea of the dangers involved during routine operations. The two large "knuckles" holding each other are the couplers. A lever operated by a crew member raises a pin that releases the knuckle for uncoupling. When coupling, an air hose under each knuckle must be manually attached, as is being done here. Then, generated by the locomotive, a valve is opened to apply air to the brakes of each car. To stop a train, each car must have its own braking system that works in concert with the rest of the train. The engineer controls all of this from the locomotive.

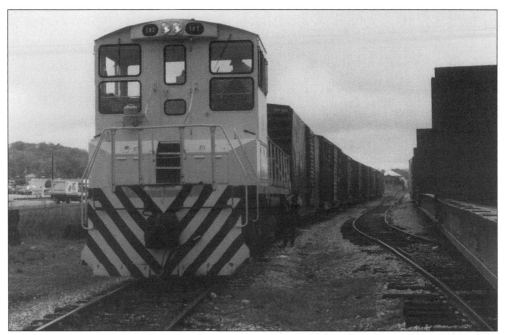

Now all set, the train is made up, and the engineer is waiting for the crew to check all the brakes before joining him in the engine for the ride to the first stop. The last CV caboose, #2855, was retired in 1977, to reduce maintenance costs. Four-man crews, equipped with radios, could all fit in the cab of the #100, #101, and #102, saving the carrier a few more dollars.

CV's piggyback service, noted earlier, began in 1964. A small ramp at the end of a track allowed trucks to ride up onto flat cars, connecting to trailers that could be delivered locally. CV management realized that trucks were biting into rail traffic nationally and hoped to keep some business for itself by handling piggyback service. Gordon Neil points out two trailers on a flat being lined up by #100 in the Lanett end of the West Point yard.

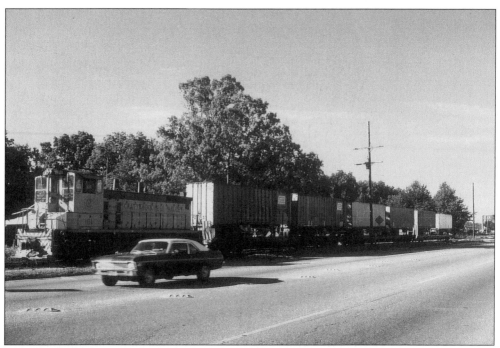

The #101 pulls three Trailer-Train flat cars off the loading track for set out into the A & WP yard. The CV handling of this service amounted to pulling the cars out of the A & WP's yard and setting them in its own. It was enough to receive a percentage of the handling profits.

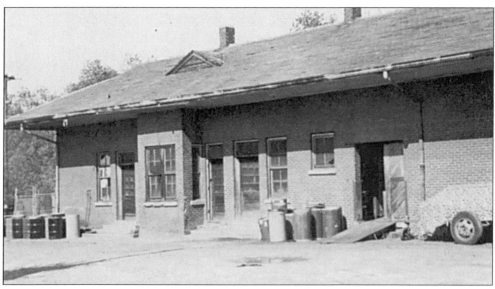

Lanett had a respectably sized station and freight house. It was located in front of the Lanett Dye and Bleacher mill on Gilmer Avenue. Farris K. Mize was the first and only agent, serving from 1921, when the building was built, to 1943. The CV and W of A had a joint agency here. It is likely the W of A paid half of Mr. Mize's salary. Railroads did this to save half an employee's salary for themselves, where enough work did not exist for two full-time positions. The building was razed in 1963.

The West Point Route, a conglomerate of the A & WP, W of A, and parent Georgia Railroad, utilized each other's equipment freely. This is a W of A local train, switching cars on the Lanett end of the yard. The crews are using a Georgia Railroad General Purpose diesel #1025 on this day. When they are done, they will head south on the WPR to Opelika, Alabama, 22 miles away, where they began their day.

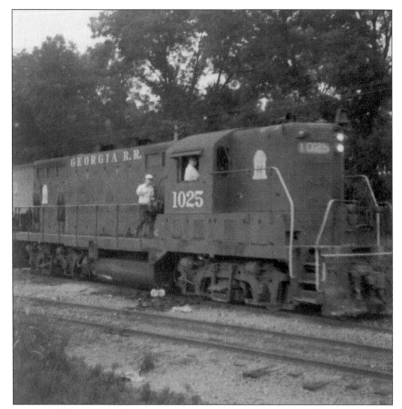

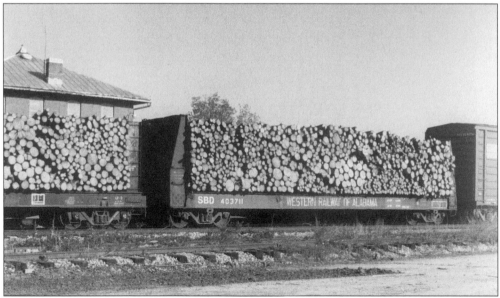

Signs of the times are barely visible in this view of a W of A wood pulp car waiting in the yard for a local train to take it somewhere. Although the car is lettered "Western Railway of Alabama," a closer look at the reporting number shows "SBD 403711." SBD was one of the merger names in WPR's history that lead up to CSX. CV management could tell railroad service around them was changing, since CSX utilized the yard less and less.

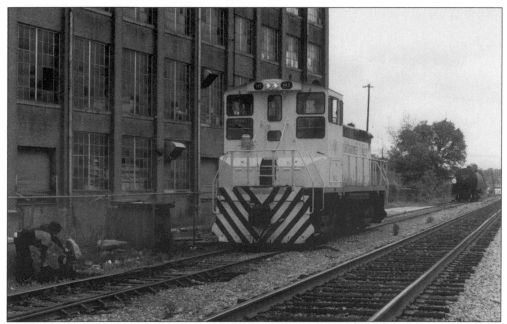

A tank car needs to be placed on one of the sidings behind Lanett Dye and Bleacher. However, the switches face the opposite direction, and there is no run-around track. Short-lines answer for this situation was to assign someone at the siding switch and to pull the engine and car towards the switch, far enough back to uncouple the car while in motion. The engineer must now speed away past the switch; then brakeman Charles Cameron throws the switch the other way.

With the engine in the siding, the tank car, under the control of Mr. Pigg, freewheels by. Mr. Pigg looks to see if the switch is clear, then begins to apply the hand brake, stopping the car. The locomotive, at the steady hand of Larry Wade, comes out, picks up the car, and backs it into the siding. They could never have just rolled the car into the siding, in case it did not stop in time. Most sidings end abruptly. It was always necessary to roll the car onto the mainline when there is plenty of time, even if the locomotive has to chase it.

Set in place, this tank car will likely be here a week before it is emptied. The CV mainline traveled through this complex between 1938 and 1955. The Lanett mill complex once used tons of coal as fuel, though it was one of the first to modernize, utilizing gas. Coal was a big portion of the CV's revenue, until all the mills converted to gas.

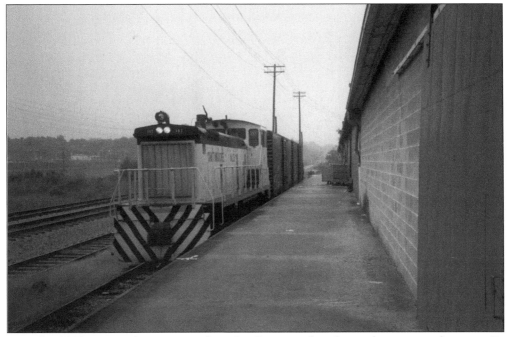

Now the CV has to get boxcars out of another Lannet siding facing the opposite direction. By the way, there was no room to install runarounds in this area, so it was necessary to couple up to cars and head back to the Lanett end of the yard.

Using the same procedure, with someone at the switch, the car is free rolled onto another open track. Conductor Baynard Dabbs holds onto a CHV boxcar with the headlight of the escaping locomotive reflecting on the car end above him. It looks easy; however, there is a lot to think about. The track next to Mr. Dabbs is the CSX mainline. CV crews must be sure, before they do a move like this, that nothing is coming along that would jeopardize Mr. Dabb's safety.

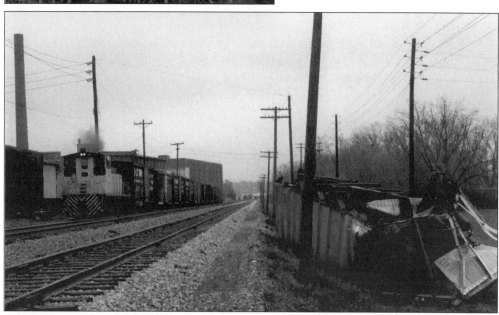

The work is done in the Twin Cities. It is time to move on down the line. The CV train is on borrowed W of A tracks behind the Lanett mill complex. The two tracks in the foreground are the W of A. The crumbled object to the right used to be an aluminum open hopper that wrecked while in one of the WPR fast freights. It was scrapped where it is. The CV train with inbound cotton is on its 1955 routing in this 1989 image. A lot of work went into building this final rerouting of the CV mainline.

Three

OFF TO SHAWMUT AND LANGDALE

Leaving Lanett, the next 3.5 miles of CV mainline was permanently relocated during the 1955 Highway 29 widening project. A tunnel was built under the W of A while that railway remained in service. The next communities along the short-line are Shawmut and Langdale. Both are a nicely arranged mixture of commercial, residential, and recreational areas. Shawmut's mill and residential area was specifically designed for harmony during its initial construction. Shawmut is an American Indian word for "living spring." Langdale is the site of one of the original mills, located alongside the Chattahoochee River. Langdale has beautiful, gently rolling hills that provide a charming setting for churches and homes but challenged CV trains traveling upward.

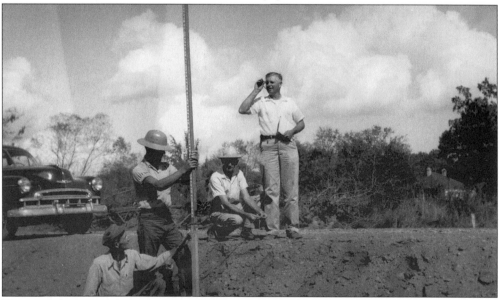

The most dramatic relocation of the CV's tracks took place in conjunction with the Highway 29 widening project funded by the State of Alabama. The CV's climb up and over the W of A, the dangerous skewed crossing over Highway 29, and the CV's intrusion through the heart of Shawmut were eliminated. Here, surveyors begin the work of marking out the new route.

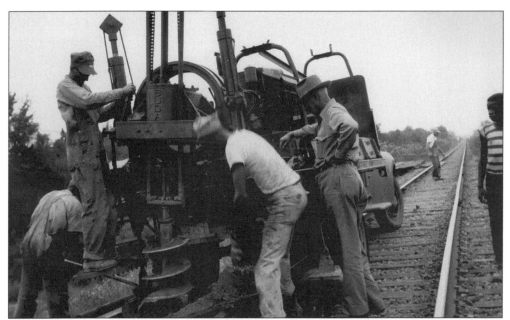

A work crew starts the process of building a tunnel under the W of A mainline. Piles must be driven to build temporary supports to hold up the track while excavation work is performed underneath. This is an auger, which is boring pilot holes for the pilings that will be driven into the earth while a youngster looks on curiously.

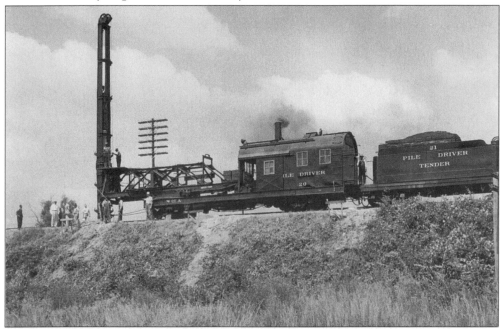

This is the Western Railway of Alabama's #20 steam-driven pile driver and its coal tender #21. Smoke drifting from its stack, this monster will pound away at wooden pilings set in the holes dug by the auger. The tall guide rack folds down on top of the machine for traveling between points. This unit can move itself short distances when working; however, a locomotive hauled it from job site to job site.

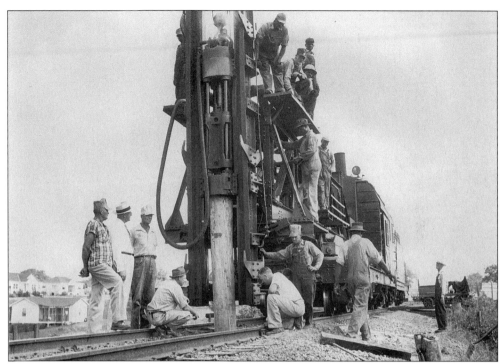

The pounding has stopped just long enough for the men to check out some specifics. The piling only has about 6 feet left above track level. W of A #20 and #21 are preserved in Atlanta, Georgia, as part of the Atlanta National Railway Historical Society's collection.

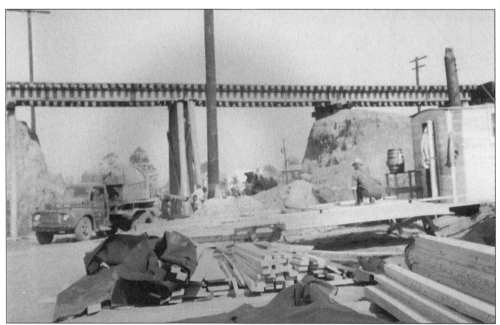

Success is reached. Temporary supports, made from the driven pilings seen next to the utility pole, hold up the track. Excavation has begun to create an opening wide enough to build a permanent support structure and allow a CV train to pass under.

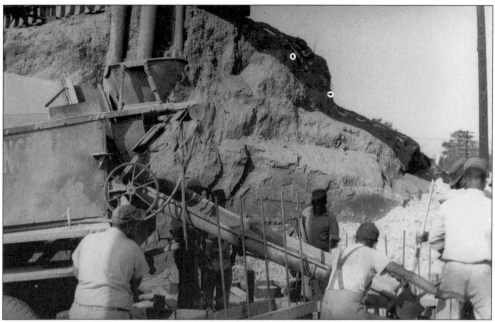

Previously made forms are now filled with cement to create the base of the permanent structure. This major undertaking created a lot of local news, as citizens watched the day-to-day progress. It became reality when the CV's daily operation was removed from sight between Lanett and Shawmut.

While the tunnel builders drive pilings and pour cement, track builders, following the surveyors markers, begin to clear the land where the tracks will be built. Chain saws rip into trees, a sound that made many residents sad. Natural, undeveloped land is somewhat sacred in many southern communities, a respect likely passed on by Native-American heritage and beliefs.

The land is leveled with bulldozers, and a subgrade fill is applied. The centerline of the proposed track alignment is kept in sight of machine operators as they dress up the right of way for good drainage and track elevation.

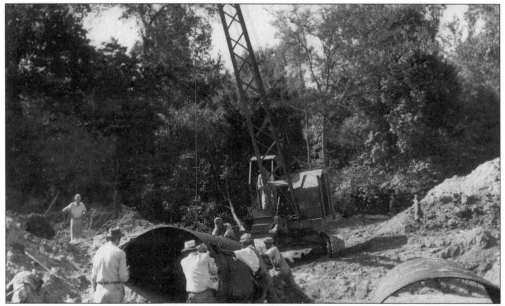

Allowing for good drainage and the cross flow of creeks is important. Water, built up around track roadbeds, weakened the substructure and caused excessive wear to the track. Culverts are installed in planned locations to provide for a calculated amount of surface water to pass underneath. These calculations were based on average rainfalls and other factors. Poor planning or extreme rainfalls caused washouts, destroying the track.

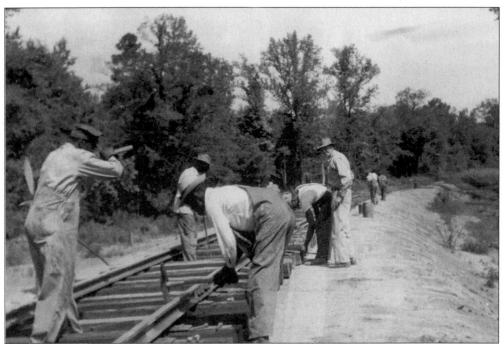

Wooden crossties are laid out and spaced apart a specific distance that relates to the maximum train speed desired. The slower the speed, the farther apart the ties may be placed, saving installation costs. Section men install spikes the old fashioned way. Swinging a spike maul over your shoulder, and hitting the spike head every time until it was fully driven, was an art. A few coins were often won betting who would miss after so many swings.

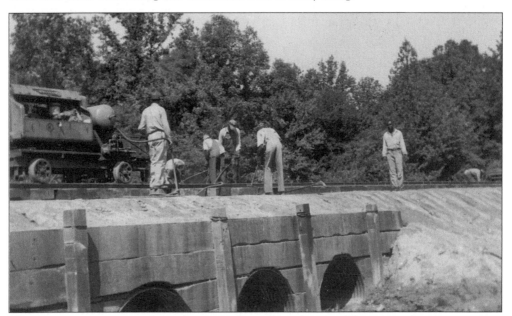

The section gang moves along, fastening the rail to the ties. This time, they are using air hammers to drive the spikes, which certainly sped up production. The culverts shown have been previously encased with cement.

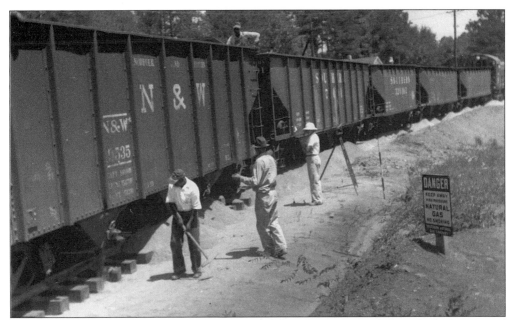

One-and-one-half-inch-sized stone, known as ballast, is being dropped through the bottoms of open hoppers delivered from the Norfolk and Western and the Southern Railways. A CV engine pulls this stone train along slowly as men open hopper pockets, distributing the stone evenly along the track. A nearby sign alerts all to a gas main underground. The surveyor is back; however, now the job is too progressed to tell anyone that the track is in the wrong place!

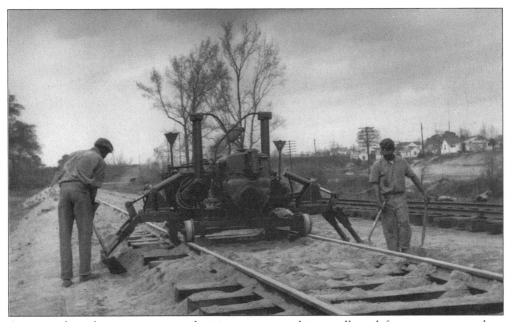

Automated track construction and maintenance machinery allowed fewer men to produce more work. Most were gasoline driven, allowing for portable and remote location operation. Small levers controlled hydraulic arms that performed many functions, preventing back and leg strain. This machine tamped earth or ballast under ties.

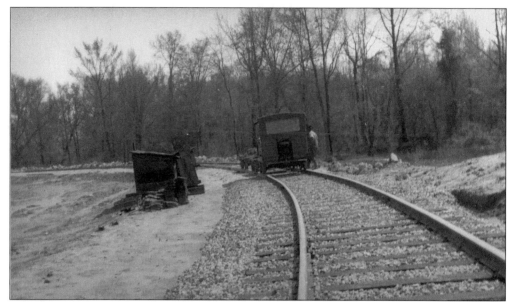

After ballast tamping and regulating, this curved section of track has the correct elevation on the outside rail to tilt the train. This allows for a faster speed with less chance of the train wheels climbing off. The vehicle on the rails is a track car. It is self-powered and can carry six men along the track to job sites, while towing flat dollies with material. The new track is done. All that is needed now is a train.

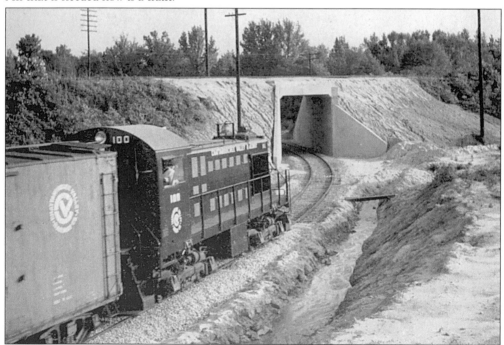

And here it is. The first CV train to use the formed cement underpass is lead by #100 on June 10, 1955. Earth fill can be seen outside the abutment walls where the original excavation work was during construction. Natural water runs in the foreground ditch away from the track structure, keeping in mind how important it is to allow for proper drainage.

Six years later, during the 1961 flood, the CV was shut down for three days due to high waters and wash outs. Section men work diligently to restore the underpass track. As much as seven feet of water rushed through the underpass during the height of the storm. The cement form itself held up very well, though all the ballast was washed away.

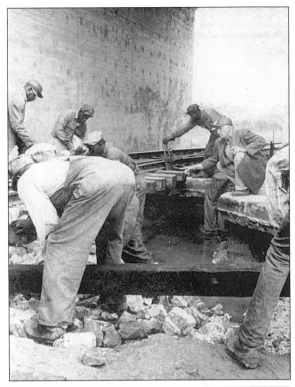

The underpass was highlighted one more time when the Services Division ordered two air-conditioning units to be delivered by the CV on flat cars. Larry Wade is checking measurement notes to see how much height clearance is required to pass the high shipment underneath. CV section men simply removed a few inches of ballast, lowering the track just enough to squeeze the units through.

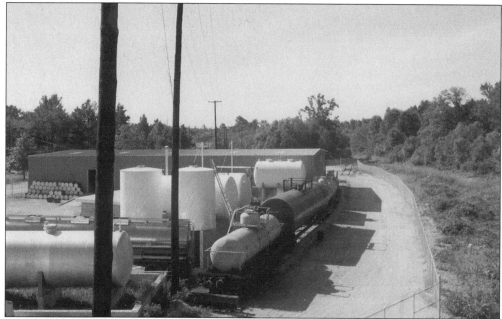

Burris Chemical was the last new customer to build along the CV (1971) and employ its services. Propane and chemicals were delivered to the company, as seen here where four different types and sizes of chemical railroad cars are lined up in this neatly kept facility. Empty cars from this facility were taken during the southbound trip. They were placed in the Langdale passing siding to be picked up, then returned to West Point.

This image was taken from the cab of a locomotive looking south. Valley Cement received sand and bulk cement in covered hoppers. The tower to the left fed cement trucks by gravity. Deliveries to Valley Cement ceased before 1989.

The #101 passes under State Highway 85, another modern competitor that invited trucks to take away some of the CV's business. As it was, the #101 is all alone with no cars in this image. This day's only business will be to move CHV boxcars from one mill to another. It is April of 1992; the final day is only five months away.

This sign, located along Highway 29 in Shawmut, boasted six towns that were the home of West Point Manufacturing mills. The city of West Point had a good identity for business, but Shawmut, Langdale, Fairfax, and River View did not. In May 1980, a new city, comprised of the aforementioned towns (except West Point), was formed as Valley, Alabama. The CV tracks originally passed just to the right of this sign.

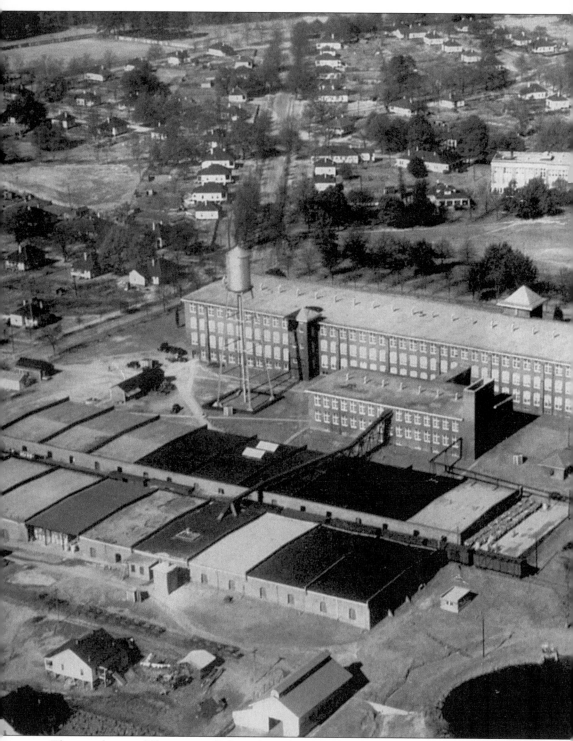

This aerial view of Shawmut mill shows how the complex and the community were designed to compliment each other. The hub section of the cartwheel-designed streets is visible. In the lower right-hand corner, boxcar roofs are visible on the original mainline. Contouring the

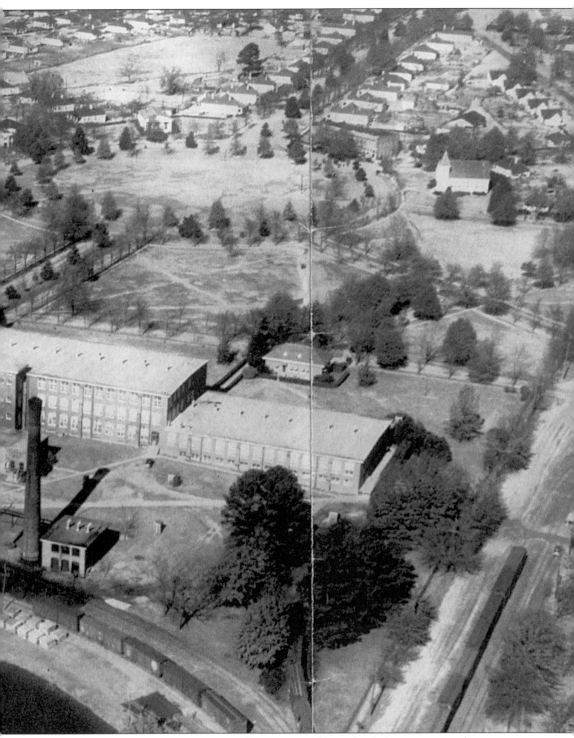

pond, five boxcars are lined up. On the same track to the left, nine more boxcars are sandwiched between the buildings. Times were busy in this 1950s view.

This image was taken from the roof of the mill building looking straight through the circular portion of the cartwheel. Homes built by the mill company surround the outer sections of the circle. The West Point Manufacturing Company was a paternal business, in many cases building the homes, schools, churches, and recreational facilities.

The negative of this image was purchased at a Valley antique shop in 1992. The image appeared in local newspapers in 1987, asking anyone if they knew where the image was taken. Scrutiny with a magnifying glass over an enlarged original print revealed the number "1" on the front of the car. This unfortunately means it is not a CV bus, as they were numbered 316 and 317. Nonetheless, it is highly representative of a time in the CV's history when the electric bus and horse-and-wagon coexisted.

78

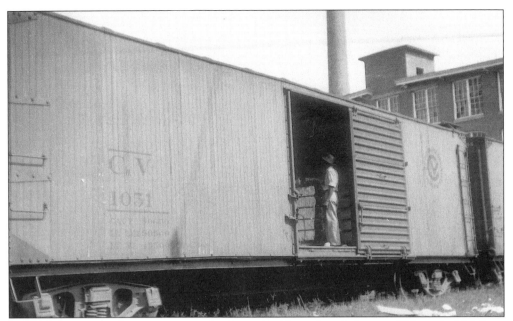

Turn-of-the-century boxcars were made of wood with steel underframes. This typical 10-foot-long boxcar had a capacity of 80,000 pounds. The door is open, offering a glimpse of cotton bales and an employee, who appears to be assessing something or just taking a break.

CHV #9002, a 50-foot car, is pushed back into Shawmut mill heading for the two buildings that sandwiched the line of boxcars on pages 76–77. When gas became the new fuel choice at this mill, coal deliveries via the CV stopped. A textile processing change inside the mill made it easier to deliver cotton to a relocated loading dock using company trucks. This single boxcar delivery was a hint of things to come.

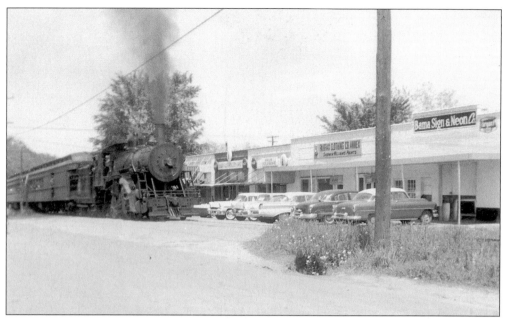

The parking lot to this row of stores along Twenty-third Boulevard in Langdale was bisected by CV tracks. It is curious why this smoke-emitting machine appeared as late as 1961. It was the return trip of the CV #21 excursion, grinding its way uphill. Two of the stores here were Bama Sign and Fairfax Clothing Annex.

The CV passed through some beautiful settings. Heading back to West Point at the end of a day, #102 passed along Moore's Creek with residential homes in the background. It was a beautiful day for fishing. School must be out—at least for this group.

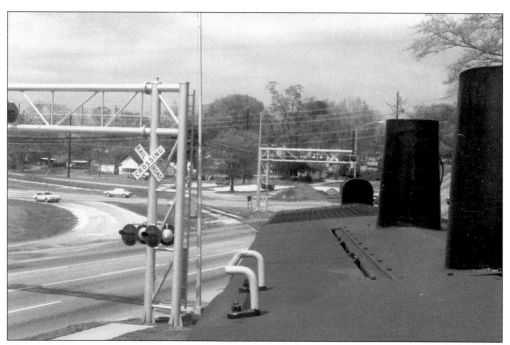

This was the view from the locomotive preparing to cross the busiest grade crossing on the CV. This is Highway 29, the same road as in West Point. More like a four-lane raceway, CV trains had to stop and then ease out onto the highway slowly until the engine blocked the whole road. Those drivers just could not wait.

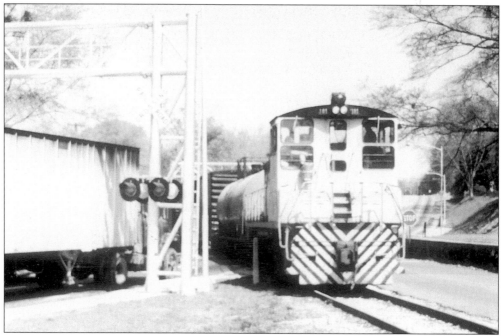

Here is a case in point. Look how close this truck stopped to a passing train, although the warning lights and bells at the grade crossing worked just fine. Despite narrow escapes, CV employees maintained a good safety record with few accidents.

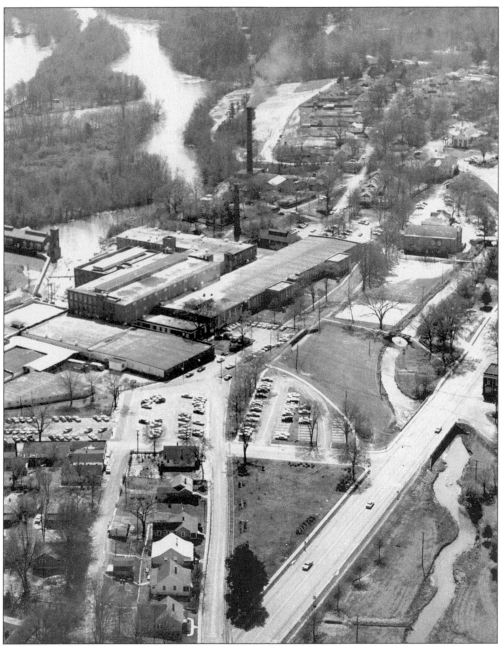

Langdale mill was one of the original two mills built in 1866. The Chattahoochee River and part of the 1909 hydroelectric plant can be seen in the upper left of the main mill complex. The CV track followed the road that goes straight up from the bottom center of the image, then veered right along the front of the flat-roofed building. Highway 29 is in the lower right, passing over Moore's Creek.

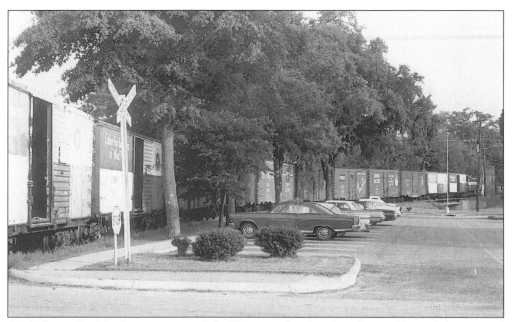

Credit Larry Goolsby for capturing a daily CV image that few thought would ever fade: a typical string of foreign cars with inbound cotton sandwiched by those CHV boxcars in the blue and white scheme. Number 100 is at the head end powering up for the grade. The automobiles are a wonderful part of this 1966 view, taken in front of the Langdale mill.

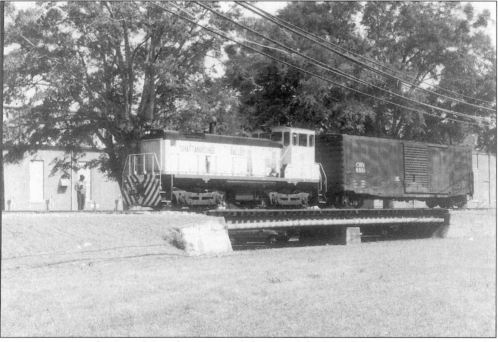

To get a car into the Langdale siding required the use of the Langdale passing track, since the siding faced northbound, and the CV arrived here southbound. Number 102 had already runaround #9001 and was passing over a short steel-beam bridge that relieves water from Moore's Creek when it overflows.

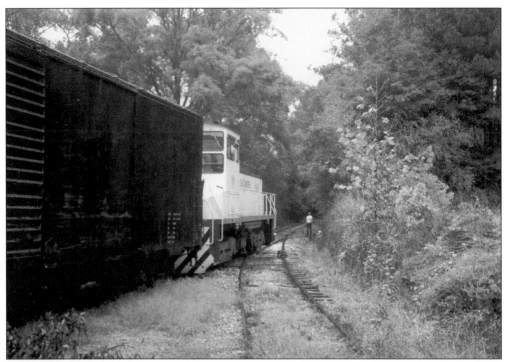

After entering the siding, the train has to make a reverse move to place the boxcar behind the mill. Here is brakeman Charles Cameron at the switch while the train pulls into a dead-end track just long enough to accommodate the locomotive and two cars.

After the train clears and appears lost in the forest, Mr. Cameron reverses the switch to the siding behind the mill. He radios engineer Larry Wade to "come on back."

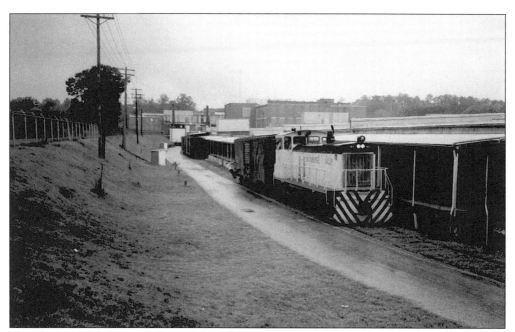

The train, with brakeman Cameron on the other end, backs up, stopping along the loading dock at a location ordered by the mill earlier in the day. Of course, the crew called the main office before they left to get their orders for the day. This is the kind of information exchanged: what car number, where it goes, etc. There are already two CHV boxcars at the end of this siding; however, no orders were received to take them away on this day.

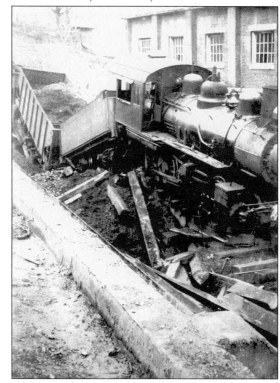

Leroy Pigg provided this image. It appears that the wooden trestle beneath this steam locomotive, its tender and one older-style coal car just collapsed. This accident is believed to be at the Langdale steam plant near the mill superintendent's home. The locomotive is a CV 0-6-0 with an unidentifiable number. It is likely that no one was hurt, just shaken up.

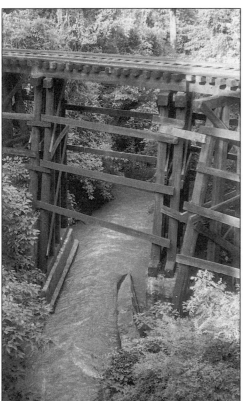

The CV had few, but very intriguing, structures to carry its mainline over, under, and around encumbrances. This short, high, wooden trestle over Moore's Creek was located just beyond Langdale mill. This little creek flooded over Highway 29 and required the relief bridge shown on page 83. The water would sometimes get to the top of the rails.

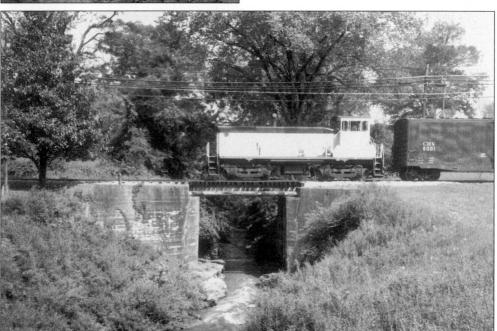

It was realized that the original bridge could not hold up against the raging floodwaters. Therefore, the wooden trestle was eventually replaced with this steel-plate girder bridge with cement abutment walls. A CV train rolls gently downhill on its way back to home base.

It was time to move on to Fairfax when the work here at Langdale was done. CHV caboose #2855 brings up the rear as this 11-car train picks up a little speed to climb the 2% grade.

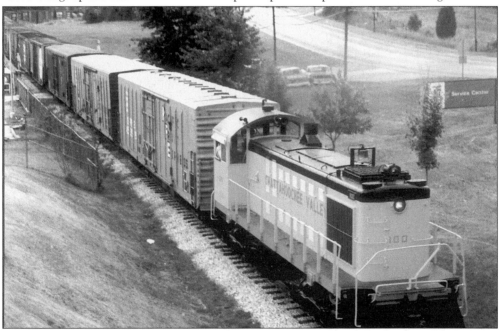

There were days when CV locomotives had to move 20 or more cars. Here, the #100 is pushing at the back of a 23-car train, while another locomotive is out of sight in the lead, pulling. The two cars next to #100 are empty refrigerated cars, normally used for produce. In order to help the A & WP keep from shipping empty cars back to their origin, the CV loaded mill shipments into these cars. The practice of using a refrigerated car for other purposes was within a fine line of Interstate Commerce Commission (ICC) tariff rules. The CV curtailed the practice to avoid a potential fine.

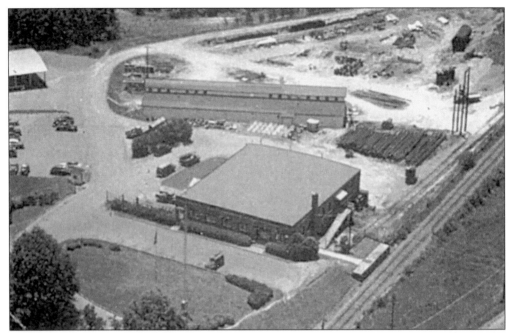

The Services Division located at Langdale was organized in 1937. It was responsible for the distribution and maintenance of electrical power to the mills and homes. It also maintained the telephone system and the water filter plant in Lanett and provided garbage collection, maintenance of streets and parks, and more. Mill-built homes were maintained by this division unit until they were sold to employees in 1953.

This is a northward view of the mainline adjacent to the Services Division. The track leading to the right was its delivery siding. The CV delivered telephone poles, sand, stone, water pipes, valves, and anything else this maintenance unit facility required. This is where the two large air-conditioning units that required the track lowering in the underpass were delivered.

Four

SERVING TOWEL CITY AND SOUTH

Fairfax was nicknamed "Towel City," since mills there produced terry cloth and towel products. This community of homes, churches, and recreational facilities is nicely integrated with the mill buildings, featuring streets of gently rolling hills lined with beautiful trees. Serving Fairfax was the CV's biggest reason for existence, especially in the railway's final years, with the construction of the Central Warehouse and the new distribution process of stored cotton. Farther down stream on the Chattahoochee River is River Dale Mill in River View. It is one of the original mills and has state lines of Georgia and Alabama running through one of its buildings. This community was once on the CV's mainline, until a southerly extension rearranged the tracks, making River View a siding. The CV of 1916 served McGinty, Blanton, McCulloh, Halawaka, Powledge, and Bleecker, where a connection and interchange yard with the Central of Georgia was maintained.

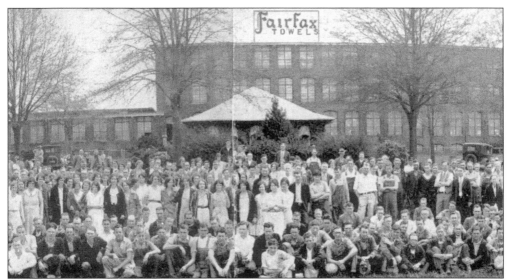

Employees gather in front of the Fairfax mill with its unmistakable "Fairfax Towels" sign proudly atop the three-story building. Built in 1916, this venture put the mill company in the towel business very successfully.

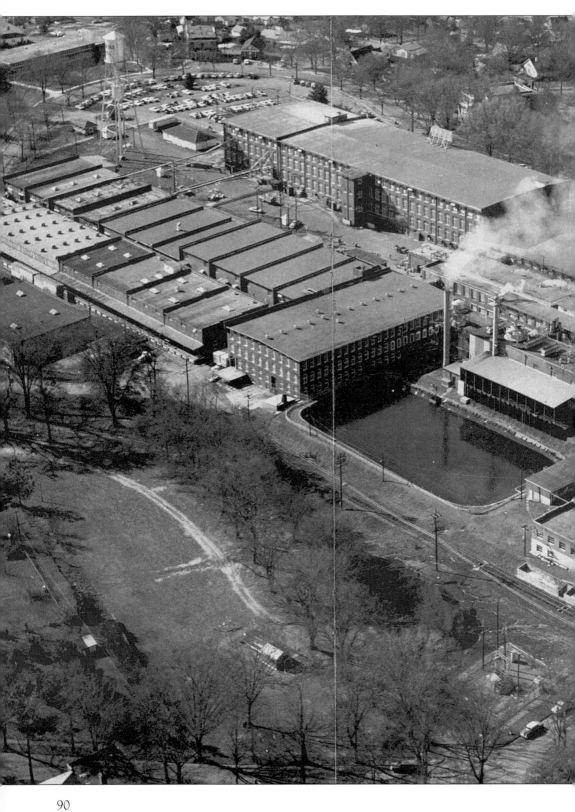

This aerial view of the Fairfax mill provides a bird's-eye view of the whole complex. The CV entered the area in the lower right corner. There were three branch sidings. One served the coal-operated powerhouse by the chimney; one provided an area for chemical tank cars; and of course, a loading dock siding had room for as many as ten boxcars for cotton and product handling.

A side benefit of building the mills and communities in close proximity was that employees could walk to work and even home for lunch. A few crowded parking lots can be seen in this aerial view, but consider that in 1953, the Fairfax mill employed more than 1,600 people and operated 966 looms.

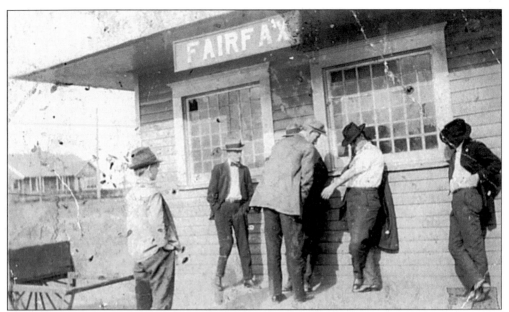

The local depot was always a place to hear news before television newscasts became a way of life. People would meet the mail train or gather to exchange information. The tall man leaning over in the center of the image is Homer D. Beck. He and four other men seem to be looking at something (perhaps a snakebite) on the arm of the man by the window.

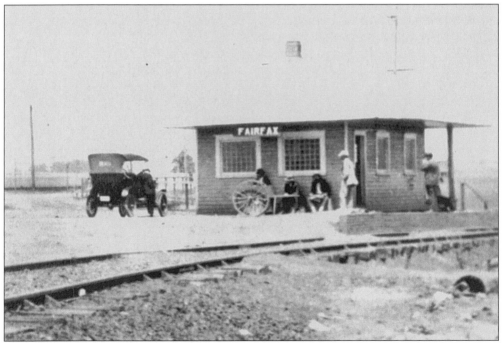

On another day, this is the same scene with different people. Someone drove to the depot in their new horseless carriage. The spoke-wheeled object visible in this and the previous image is a small baggage/mail wagon used by the agent to exchange parcels with the baggage man in the baggage car when the train arrives.

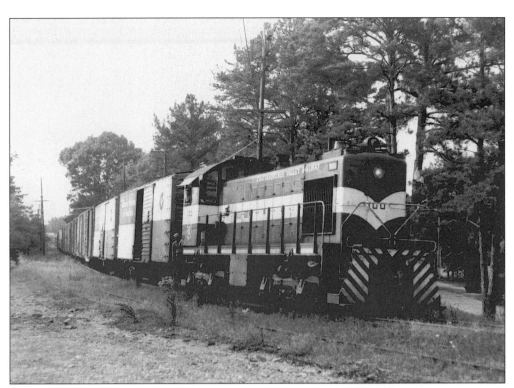

Number 100 has 10 boxcars and a caboose as it rolls by the passing siding at Fairfax. Fairfax was a busy place, requiring railway employees to have a plan for setting out and picking up cars and to stick to it. A slight distraction could be injurious.

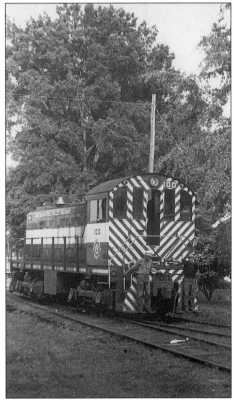

Conductor Baynard Dabbs is on the right. Conductors were responsible to determine the best plan to move the cars and instruct everyone else of the plan. Those stripes are intriguing. In World War II, painting a ship like this was known as "dazzling," an illusion that made ships on the horizon "invisible." In railroading, the intent was just the opposite. Striping such as this was intended to alert anxious motorists at grade crossings to see the train. These zebra stripes provided an unmistakable message to stop.

Conductors and brakeman spent most of their day holding onto the sides of freight cars, like brakeman Fred Price is doing in this photograph. As the train moved back and forth and in and out of sidings, cars had to be coupled and uncoupled in various locations throughout the train. In addition, when backing up, an employee had to be on the end car to guide the engineer pushing from behind who could not see.

When no one was around, others hung onto the sides of cars as well. Located in the center in her white dress is Lottie Eva Kinney Beck. To the left is Fannie Kinney Scales, her sister. All three women are smiling big for the camera. There is a pile of coal on the ground nearby, which hopefully will not soil their nice clothes.

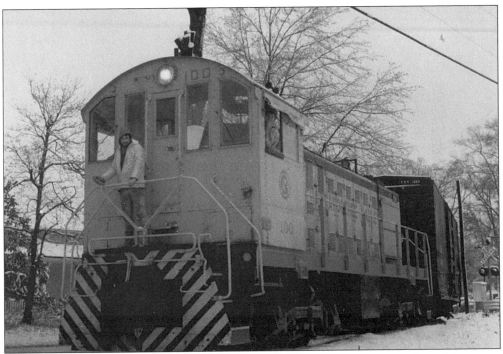

The southeast is known for its mild winters and long growing seasons. Something went wrong this day, as brothers Randall and Montgomery Moody deal with a few inches of snow. Wet rails make the locomotive wheels slip, challenging engineers not to destroy the top of rails. Number 100 is coming up from Fairfax mill as Montgomery protects the crossing from the front of the platform.

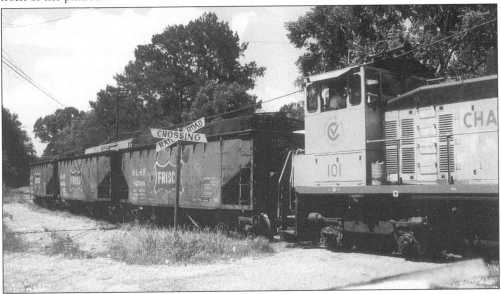

Three open hoppers are placed on the siding, having just been removed from the Fairfax powerhouse track. It will not be long until gas will be used as a fuel. Number 101 has the honors on this day. Once business required only one train a day, the CV alternated use between the #101 and the #102.

Officials often met on various railroad properties to inspect facilities and discuss transportation business. CV equipment, including the #349 and Central Park, were generally used to host guests visiting the CV area. On this day, a Central of Georgia locomotive, #809, and its special train have pulled into Fairfax. Roy Harrell (right) was West Point's traffic manager. Paul McCoy, whose hands are visible out of the cab window, served as engineer of the special, celebrating the 23rd Annual Industrial Tour of the Birmingham Traffic and Transportation Club.

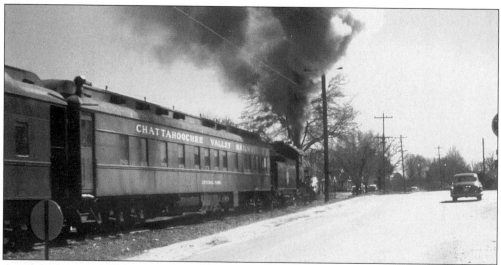

Another excursion, this one for the public, was the 1961 Atlanta to Bleecker trip over the A & WP and CV. Howard L. Robins photographed #21 blasting through Fairfax just beyond the depot with Central Park right behind. With a full head of steam, the engineer will soon have an easier time of it as the crest has been reached.

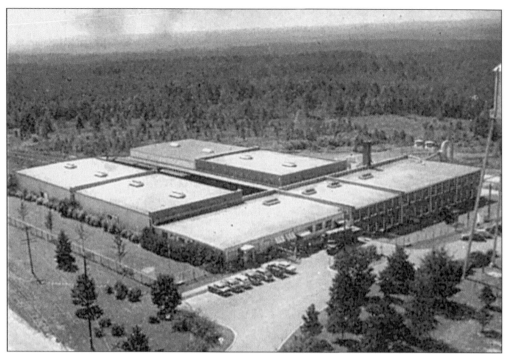

The West Point (Manufacturing) Utilization Company was built in 1916 because of textile leaders realizing that cotton waste was a valuable resource. The Utilization Company, in its first year of operation, handled up to 15 million tons of waste, turning it into useful material for bedding, furniture, upholstery, and automotive uses. When synthetics like rayon were introduced in the mid 1940s, the facility installed machinery to process those wastes as well.

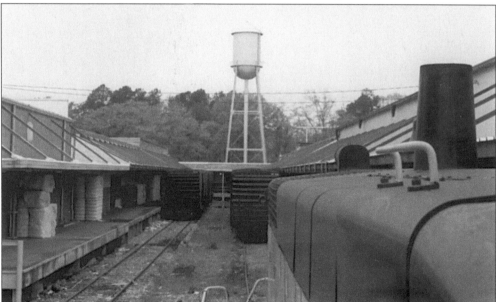

The familiar water tower of the Utilization plant was always visible to the engineer as he backed into one of the two sidings. The white stuff on the ground is not snow this time; it is wayward cotton.

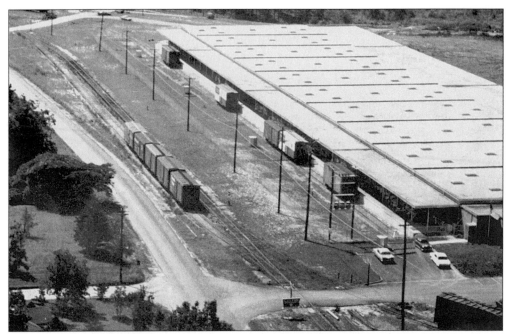

In 1961, to accommodate fluctuating cotton prices, the textile company opened a one-million-square-foot Central Warehouse. It was built to hold cotton purchased in gluts when the price was right. CV trains of up to 30 boxcars laden with the white staple were placed along side the warehouse for unloading. In 1969, the CV handled 161,000 tons of cotton, not including the rehandling of waste cotton, using 6,500 boxcars.

Built next to the Central Warehouse in 1962 was a specially designed warehouse that efficiently stored and provided for shipment of finished goods. Both the CV and the textile company's motor truck fleet served this distribution center.

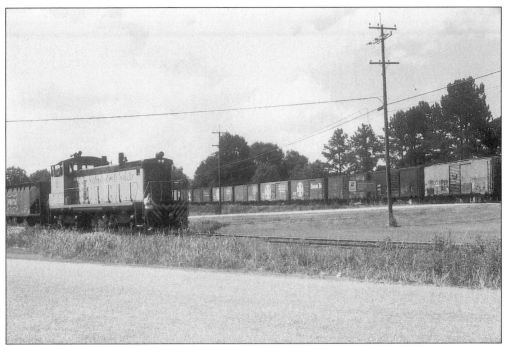

Switching cars in and out of the two warehouses was a chore for employees. The sidings were curved and on grades, requiring good communications by hand and radio. On the mainline waits more than 10 boxcars, as #101 pulls up a string of cars to join them.

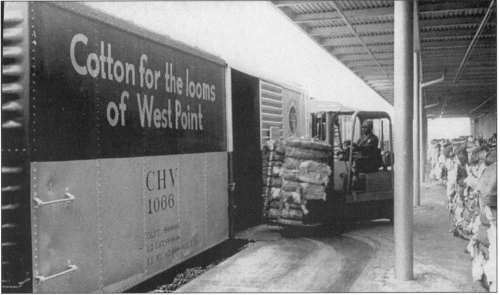

CV's 40-foot-long boxcars had a weight capacity of 80,000 pounds. Cars such as CHV #1066 were loaded with cotton from within the warehouse and transported the material to the various mills upon request. "Cotton for the Looms of West Point" said it all.

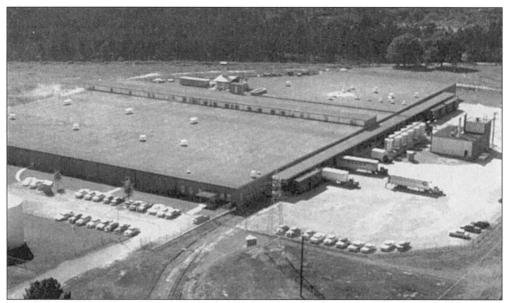

The Lantuck Division was built in 1955. It received shipments in both boxcars and chemical tank cars. Lantuck is the patented name of a material held together with an adhesive. Its uses include automobile seat backing and waterproof table clothes. The CV served this facility frequently.

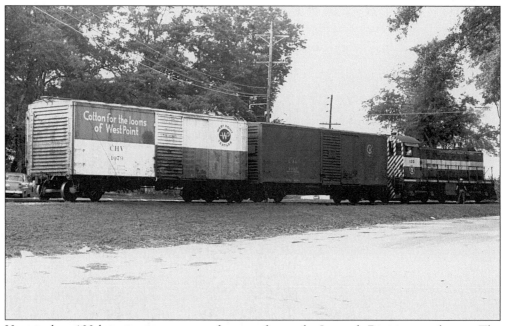

Here is the #100 bringing in two cars of cotton for use by Lantuck Division employees. The car next to the locomotive is CHV #1062, in the original drab paint style. CHV #1079 is showing signs of wear only five years after being freshly painted. The CHV all-black-boxcar era followed soon.

A slow downhill ride to McGinty along the CV provided a respite after switching the busy Fairfax area. At McGinty, with its familiar general store and crossroad intersection, the CV established a maintenance-of-way area. To the right of the CV mainline are several metal sheds containing track maintenance equipment. Stacked outside were standard 39-foot-long lengths of reusable rail salvaged from abandonments such as when McGinty became the end of the line in 1974.

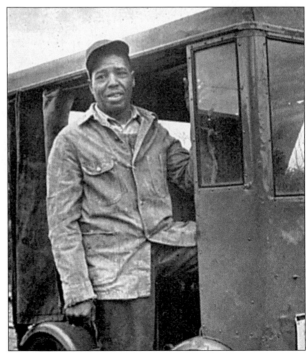

Maintenance-of-way employees were the backbone that kept the tracks and structures in good condition, keeping trains on the track. Joe Cochran, a section hand, joined the CV in 1930. Joe is seen here in the mid-1950s on board a motor car.

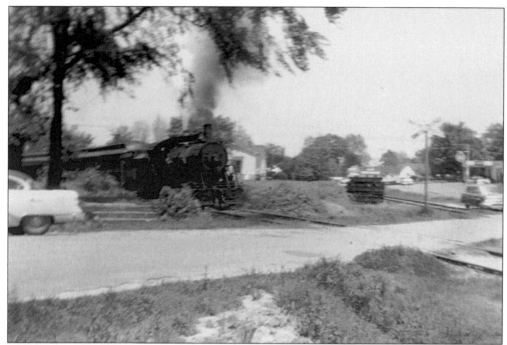

Again, the 1961 CV excursion gets in the picture. Lead by #21, the train whistle is sounded, relaying to everyone that this is the end of steam for the short-line. Many long-time residents enjoyed the sounds of CV locomotives whistles. The train is on the mainline heading south. To the right is the siding to River View.

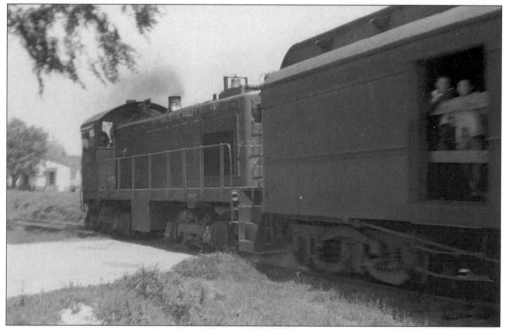

Pushing the excursion train from behind is #100. Through radio communications, the rear engineer was told when to push. Braking of the train was controlled in the lead locomotive. Two youngsters enjoy the open air in a baggage car with safety bars protecting an open door.

The River Dale mill was built in 1866. It was from here to Langdale that barges transported goods before the railway. The mill used flowing water of the Chattahoochee River to generate electricity. Mill employee Ervin Anthony is fishing in the river on the Georgia side of the mill.

After backing up about 2 miles from McGinty, the CV sat cars on two sidetracks situated very close to river water. Three 50-foot-long cars are left on one track while cars from the other track are taken out first. Switching in River View was fairly easy, since you only brought the cars you needed while the rest of the train waited at Fairfax.

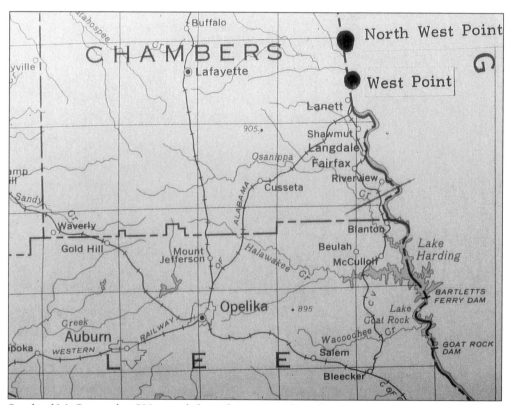

South of McGinty, the CV passed through towns and small communities, some of which are now gone. Through this area, over the years, the CV would pick up cars of locally grown cotton and wood pulp. The main reason for the next 17 miles of track was to connect with the C of G for cost savings.

As CV trains grew, their increased length required that they cross roads at a decent speed, so warnings to motorists were installed. Two CV men have just installed such a warning on a road that curved before the grade crossing near Blanton.

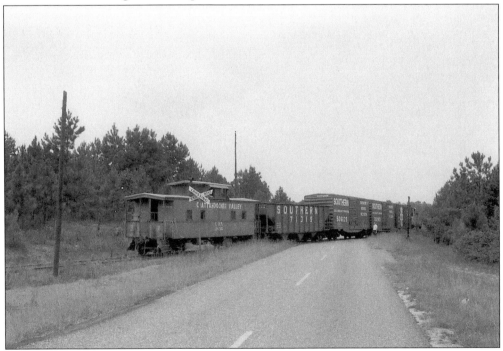

It is the early 1970s, and the CV already filed for abandonment of this section of track, in part due to anticipated costs of track maintenance required by a new Federal Standard. A train crosses over a road with CHV #2855 bringing up the rear. A CV brakeman waits alongside and will step onto the caboose for the ride to Bleecker, which is not far away.

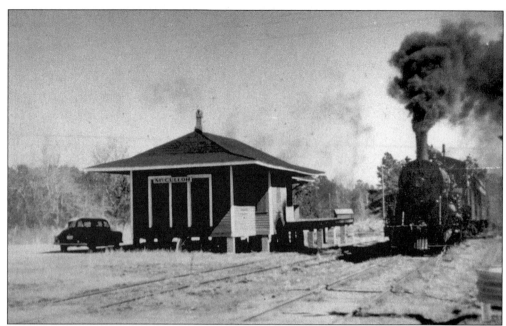

McCulloh Station was a simple wooden structure, built up on bricks, that served two purposes. The combination passenger and freight depot had a platform high enough to match boxcar floors for easy unloading. The second reason was that anything made of wood that touched the ground was eaten by ants. Number 21 and the excursion train are preparing to rumble by the station and road crossing.

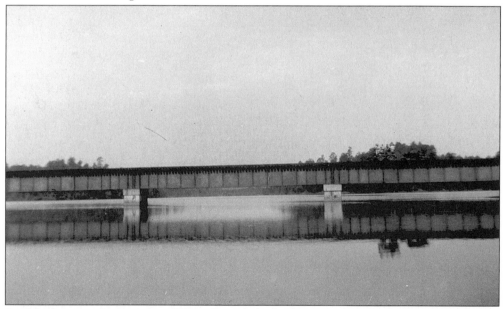

Steel bridges were built to carry CV tracks over the backwaters of the Osanippa and Halawakee Creeks in 1926. A new dam at Bartlett's Ferry, to which the CV delivered fill material, created these backwaters. Forrest Hornsby provided this view of one of the CV's steel bridges. Look closely in the reflection of the water to the right. It is the reflection of section men on a handcar pulling a dolly over the bridge.

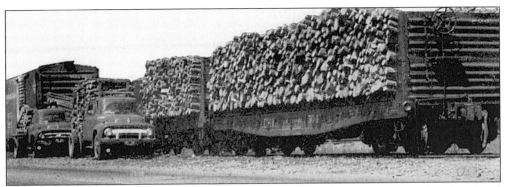

Wood pulp was delivered to the CV in small trucks, as seen here. It was transferred by hand onto CHV cars for shipment to buyers. CHV #504 is loaded to the top, requiring deliverymen to start loading the next car. The CV train will be along to take these two loads and leave two empties behind to keep the process going. In the 1950s, wood pulp handling totaled 8% of the CV's business.

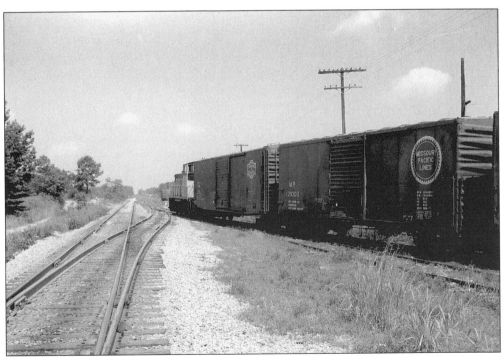

Bleecker interchange yard was the last stop on the south end of the CV. To the left is the C of G mainline from Columbus, Georgia, looking towards Birmingham, Alabama. The CV train is returning empties, one of which includes a boxcar from another nearby short-line, the Savannah and Atlanta Railroad.

Don Cogdell provided interesting memories about the CV. As it was, Mr. Cogdell's mother was the C of G agent at Bleecker. Half her salary was paid for by the CV, saving both companies half a salary where one person could handle all the work. This *c.* 1945 image shows Mr. Cogdell in his military uniform, his wife, and his father with the Bleecker station in the background.

Mrs. Cogdell served the C of G and CV while raising her family in the shadow of the railroad's operations. (Their home was right by the Bleecker depot.) Her son, Don, remembers the icehouse on the CV section and riding steam locomotives as they turned around on the "Y" track.

108

Five

SO LONG, CHATTAHOOCHEE VALLEY RAILWAY

The CV provided service for 97 years. Its contributions to the area it served, economically and socially, are etched in the minds of many. On September 25, 1992, the last two outbound cars and all the CV's equipment were pulled together back to West Point yard for final disposition. The sound of the CV's whistles were silenced; automobiles would race across grade crossings obliterated by the dismantling of the railway, and trucks would handle the business of the newly formed corporations of the former textile company. Preserved CV equipment and a new hiking trail will help educate those who did not know the CV.

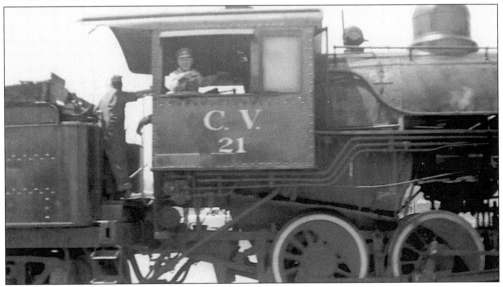

Heading back from Bleecker on the return trip of the 1961 excursion, engineer McCoy waves at photographer Bill Cooper.

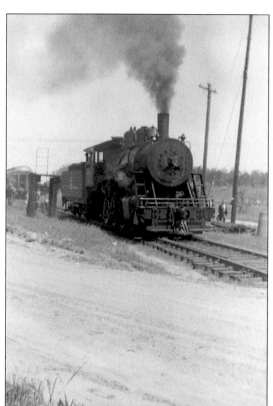

On the east leg of the "Y" at Bleecker, the special backs up against the train while riders stretch their legs.

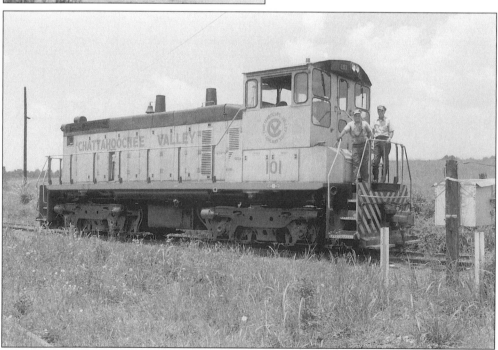

Two crew members take a second to pose at Bleecker before using the telephone box to get permission back to West Point.

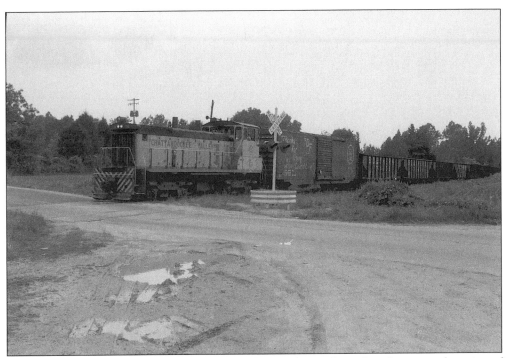

Number 101 crosses the grade at McCulloh with an Atlantic Coast Line boxcar and a string of Southern hoppers for the dam project.

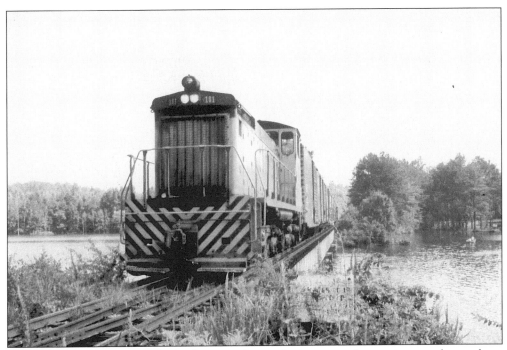

Here, #101 is crossing over the back waters during the last year of operations on the southern portion.

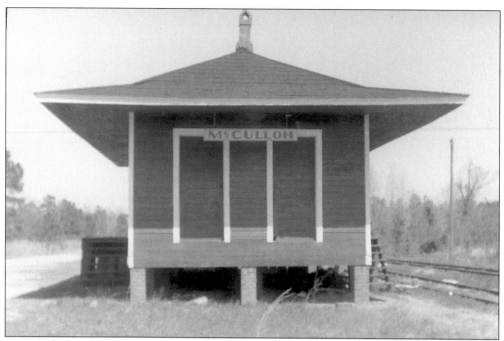

McCulloh depot is still standing on this day. It was sold to a local resident in 1974, when the CV no longer had any use for it.

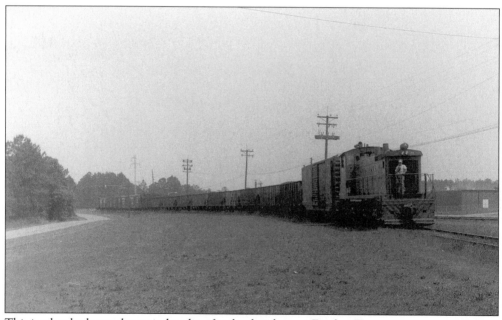

This is a last look at a slag train heading for the dam here at Fairfax. Twenty-one cars are in tow, as a CV employee pilots the train cooling off in the breeze.

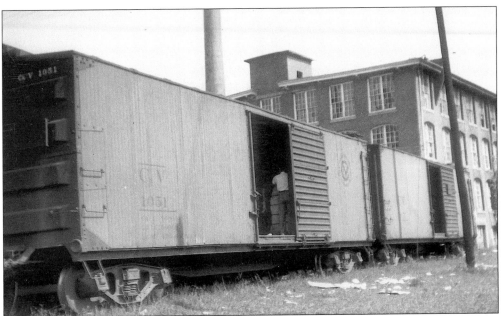

This early car is actually marked "C.V. 1051." Images of boxcars parked at mill loading docks with cotton visible through open doors are no more.

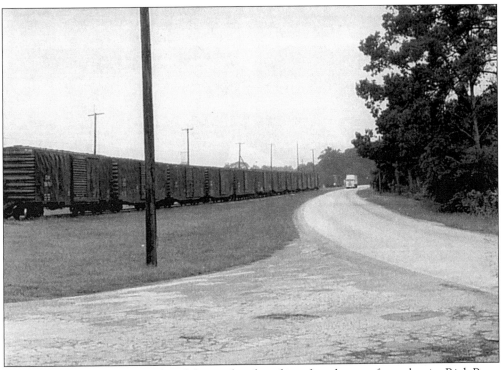

The last train over a section of track being abandoned is referred to as a funeral train. Rick Perry photographed the funeral train in Fairfax, as the CV crew collected every piece of equipment for the run back to the main yard.

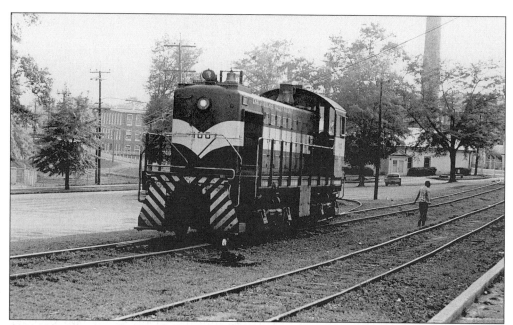

CV #100 will never again back down into Fairfax mill with coal, chemicals, and cotton. It will never deal with occasional snow either.

Engineer Larry Wade and conductor Baynard Dabbs enjoy a lunch in the engine cab, some time after the CV sold all its cabooses.

The Fairfax depot still stands today, likely becoming a stopping point on the trail. It served as Valley Grocery store for a time, before big supermarkets and malls became popular. Note the New Jersey license plate on the station wagon.

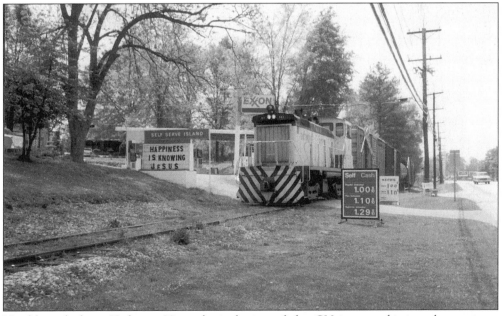

Northbound along Highway 29, a classical view of the CV is seen skirting along private property in the mix of daily life. A horseshoe driveway into this gas station created two crossings for the CV, which appears to be fueling up at the Exxon station.

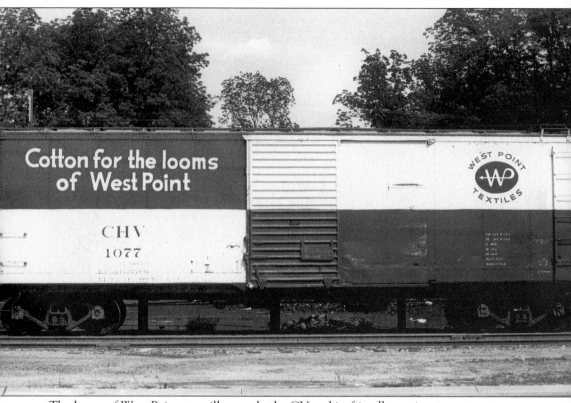

Cotton for the looms
of West Point

CHV
1077

WEST POINT
TEXTILES

The looms of West Point are still at work; the CV and its friendly service are not.

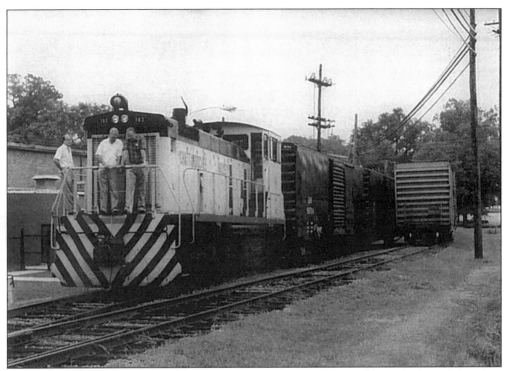

Three visitors ride the pilot as the crew makes a move to pick up cars at the Langdale siding during the last day of operations.

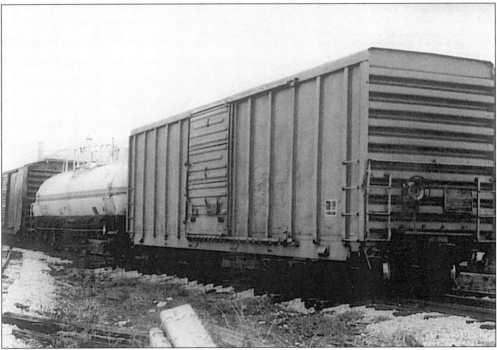

The last two foreign cars off the CV are set out at West Point yard for the local CSX train to return to their owners. All good things must come to an end.

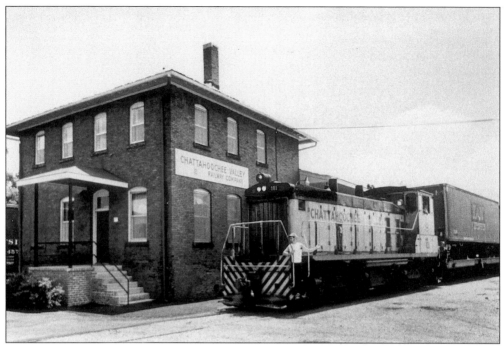

The days of switching trailers on flat cars in front of the CV headquarters ended in 1980.

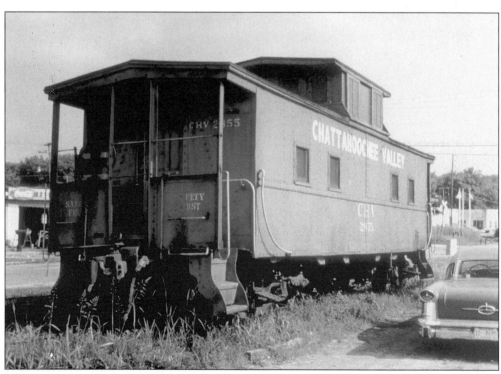

Charlie Houser photographed CV's last caboose, #2855, which was sold in 1977.

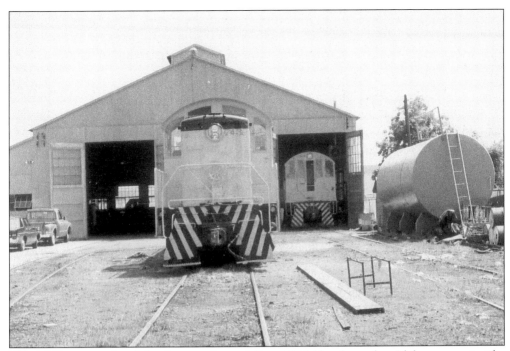

The #743 is outside of the Lanett shop while #100 hides from the Alabama sun inside. Wherever these two faithful units are today, for sure they do not wear the attractive yellow and red CV paint scheme.

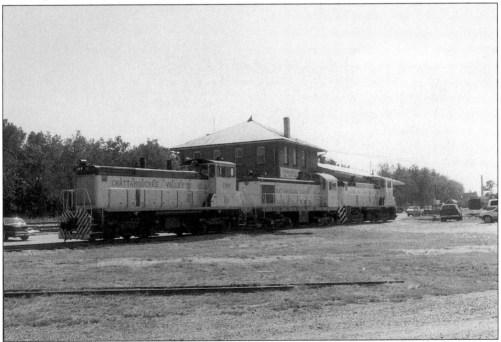

All lined up are three CV diesels that served together for about one year. From left are #101, #100, and #102. Number 100 was sold in 1989; #101 and #102 were sold to the Tennessee Valley Authority in Stevenson, Alabama, in 1992 at the close of CV business.

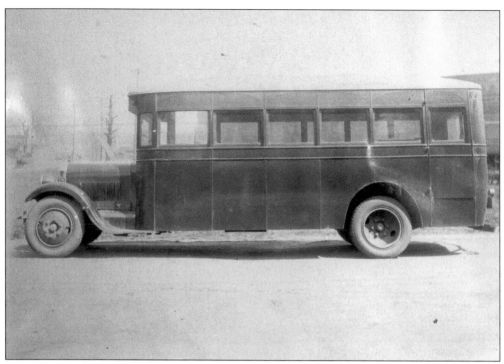

From the scrapbook album is this view of the CV bus that operated over the highway stenciled "Chattachoochee Valley Transportation." It was sold when passenger service ended in 1932.

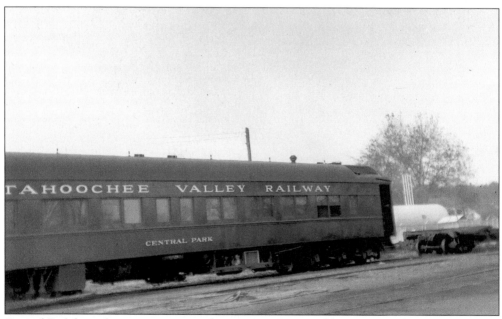

Central Park hosted many meetings and excursions. It was sold in 1965; with it went an era of business people getting together outside the office to discuss the future.

The CV cared about the community, participating when it could. Here, a CV maintenance-of-way truck serves as the base of their float during the 1954 Valley centennial parade. On the CV float are the following, from left to right: Sue McGhee, Faye Crowder, and Betty Bailey.

THIS AWARD IS MADE TO THE EMPLOYEES OF

Chattahoochee Valley

Railway Company

WHO ARE BUYING WAR SAVINGS BONDS AT THE RATE OF MORE THAN 10% OF THEIR EARNINGS THROUGH A SYSTEMATIC PURCHASE PLAN

Henry Morganthau J

SECRETARY OF THE TREASURY

EXECUTIVE DIRECTOR
WAR SAVINGS STAFF

CV employees cared well beyond their own community. Then U.S. Treasury Secretary Henry Morganthau Jr. commended the CV people for contributing more than 10% of their earnings to war savings bonds.

Employees consisted of managers and the office staff that worked in the headquarters buildings. A group here with the #349 includes well-regarded CV president R.J. Morton, who served in that capacity from 1941 until his passing in 1966.

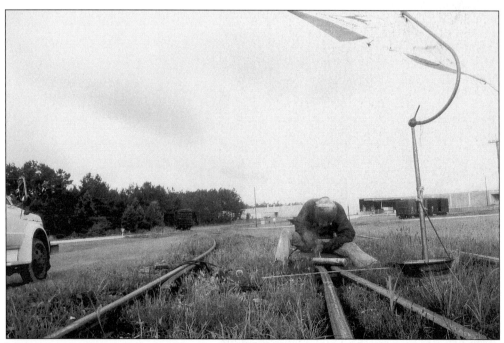

Maintenance-of-way employees like Danny Hadaway kept the track in good condition. Here, Danny welds a switch point worn down by the back and forth movement of train wheels.

Engineer Wynton Partridge began his career as a section hand in 1931. He was one of the crews that operated to Bleecker daily in 1954.

Conductors and brakeman were charged with moving cars around in a timely and safe fashion. W.A. McWhorter holds on while signaling to the engineer.

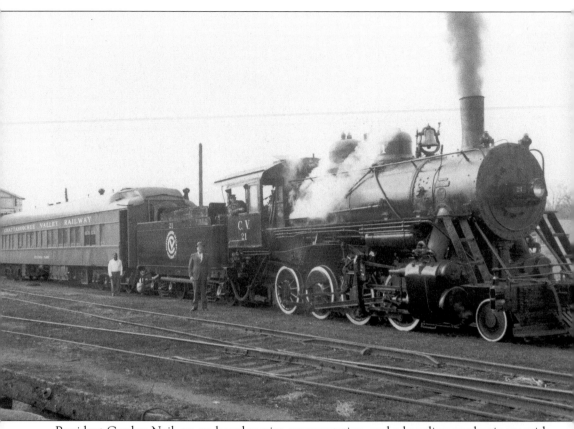

President Gordon Neil, an on-board service representative, and a kneeling mechanic are with famed pair #21 and Central Park. The occasion was that on this day, Number 21 would be donated after the excursion. Every aspect of the locomotive is cleaned and shining, typical CV first class.

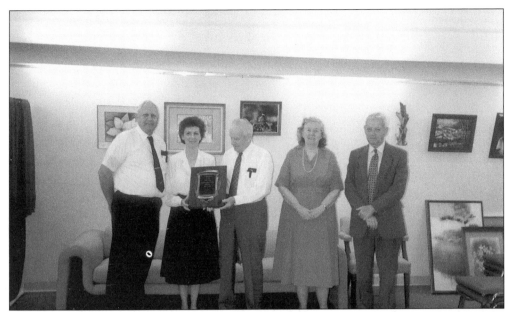

In April of 1992, this author convened a CV Employee and Friends Reunion at the H. Grady Bradshaw Library. Accepting the commemorative plaque are, from left to right, as follows: Leroy Pigg, Kathleen Shaddix, Gordon Neil, Mrs. Irene Haralson, and E.G. Hurley.

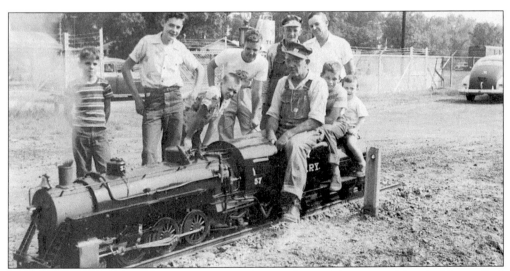

Surrounded by a group of youngsters marveling at his miniature machine is Mason Paul McCoy. Mr. McCoy, seated on the miniature CV #57, was a master mechanic retiring with 49 years. He built this small-scale locomotive that actually burns coal and can pull a miniature trainload of people.

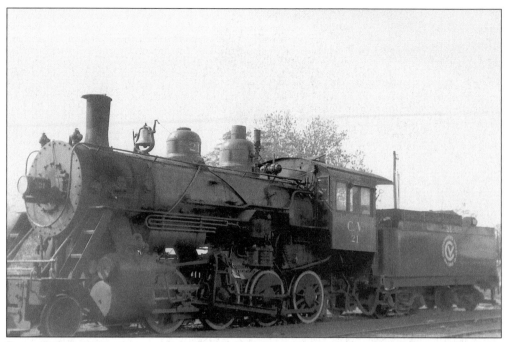

From 1947 to 1961, #21 provided a chugging puffing image of railroading through Valley, the way it used to be.

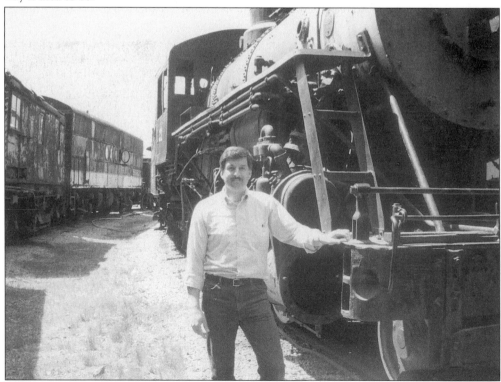

The Atlanta National Railway Historical Society was the recipient of some CV equipment, including boxcars and maintenance-of-way equipment. Here, the author visits #21 in storage.

The lead to the warehouses in Fairfax is partially dismantled. A contractor removed the entire 10 miles of CV tracks, selling or scrapping rail and ties depending on their condition.

Lona Joyce (Hornsby) Gallo recorded an image of the new hiking trail near Fairfax in 1999. The trail serves as a recreational and educational heritage path.

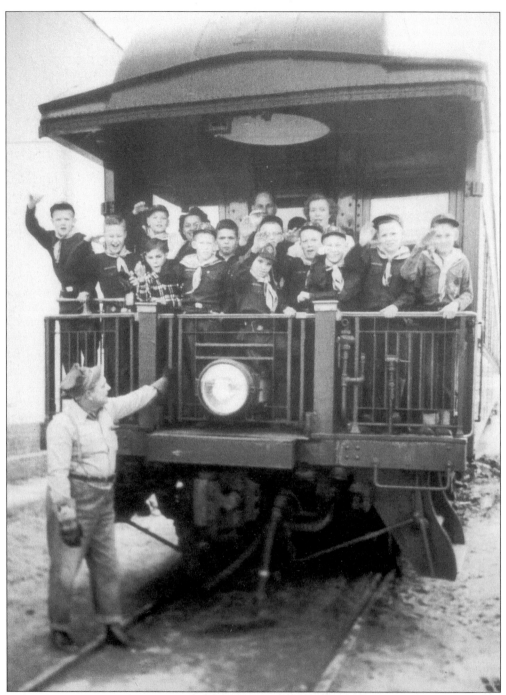

Cubs of Pack 42, Huguley, are on board one of the many benevolent trips CV provided. The cubs pictured here are, from left to right, as follows: Drew Hall, Barry Waites, Billy Kelly, Eulus Williams, den mother Virginia McVay, Mike Spear, Waynon Harper, cubmaster Alton Waites, Gary Clanton, Tommy Harris, den mother Julia Abney, Allen Robins, Johnny Rearden, Dale McVay, and Tommy Klaus. Flagman Rufus Kennon signals the pack to wave and say, "So long, Chattahoochee Valley Railway."